MW01078848

Marsden Hartley
IN BAVARIA

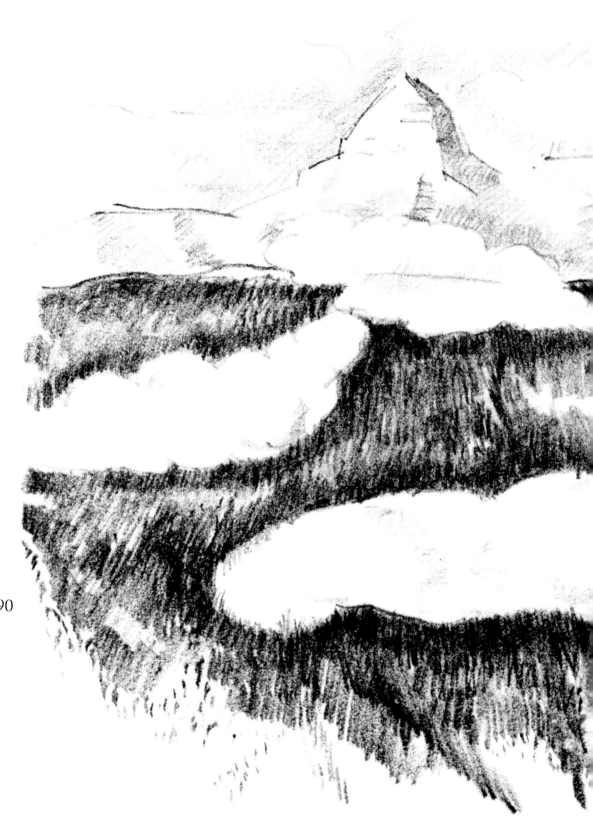

This exhibition is supported
in part by a grant from the
National Endowment for the Arts,
a Federal agency; the
Albert A. and Vera G. List
endowment; and funds
donated by the
Hamilton Friends of Art.

Emerson Gallery, Hamilton College
Clinton, New York
September 23 - November 5, 1989

Milwaukee Art Museum
Milwaukee, Wisconsin
November 30, 1989 - January 28, 1990

Bowdoin College Museum of Art
Brunswick, Maine
February 15 - April 15, 1990

Baruch College Gallery
of the City University of New York,
New York
May 2 - June 7, 1990

Marsden Hartley
IN BAVARIA

Gail Levin, Guest Curator

An exhibition organized by
William Salzillo

Emerson Gallery, Hamilton College

Distributed by the University Press of New England,
Hanover and London

Frontispiece: After
Alpspitze from Eckbauer, 1933
Pencil on paper, 8 7/8 x 11 3/16 inches.
Collection, Georgia Museum of Art,
The University of Georgia
Cat. No. 51

Photo credits:
Carl Hecker; cat. 54
Emil Ghinger; cat. 10
Gail Levin; Fig. Nos. 11-18
Otto E. Nelson; cat. 9
David Tewksbury; cat. 4, 7, 16, 17
Archives of American Art, Smithsonian
Institution; Fig. Nos. 1 & 2

Photographs for catalogue numbers not
listed were provided courtesy of the
lending museum or collector.

ISBN-0-87451-516-5

Library of Congress Catalog Card Number 89-085500

Design by Grant Jacks
Printed by Penmore Lithographers, Lewiston, Maine
Copyright © 1989, Emerson Gallery,
Hamilton College, Clinton, New York, 13323
Gail Levin's essay and photographs © 1989, Gail Levin

▶
Cat. No. 25
Bavarian Mountains [Dreitorspitze],
1933
Conte crayon on tracing paper,
10 x 13 3/16 inches.
Collection, The Cleveland Museum of Art,
Norman O. Stone and Ella A. Stone
Memorial Fund

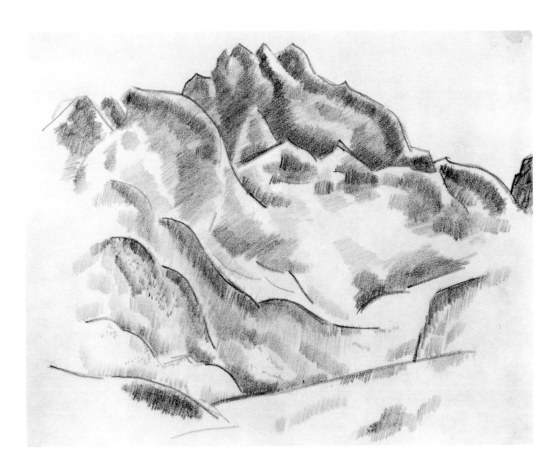

CONTENTS

LENDERS TO THE EXHIBITION

Mr. and Mrs. David K. Anderson

The Art Museum, Princeton University, Princeton, New Jersey

Babcock Galleries, New York

Robert and Barbara Bachner

Lois Borgenicht

The Carnegie Museum of Art, Pittsburgh, Pennsylvania

The Cleveland Museum of Art, Cleveland, Ohio

Colby College Museum of Art, Waterville, Maine

Emerson Gallery, Hamilton College, Clinton, New York

Mr. Gerald Ferguson

Georgia Museum of Art, The University of Georgia, Athens, Georgia

Mr. Edward Glannon

Heckscher Museum, Huntington, New York

Herbert F. Johnson Museum of Art, Cornell University,
Collection of Willard Straight Hall, Ithaca, New York

The High Museum of Art, Atlanta, Georgia

Hirshhorn Museum and Sculpture Garden,
Smithsonian Institution, Washington, D. C.

Kalamazoo Institute of Arts, Kalamazoo, Michigan

Mead Art Museum, Amherst College, Amherst, Massachusetts

Victoria Miller

Milwaukee Art Museum, Milwaukee, Wisconsin

Museum of Art, Olin Arts Center, Bates College, Lewiston, Maine

The Museum of Modern Art, New York

Roald and Susan Nasgaard

Oklahoma Art Center, Oklahoma City, Oklahoma

Owings-Dewey Fine Art, Santa Fe, New Mexico

The Regis Collection, Minneapolis, Minnesota

Juliet and Michael A. Rubenstein

Salander-O'Reilly Galleries, Inc., New York

Santa Barbara Museum of Art, Santa Barbara, California

Mr. Peter Selz

Sheldon Memorial Gallery, University of Nebraska, Lincoln, Nebraska

Sid Deutsch Gallery, New York

Dr. and Mrs. Marvin Sinkoff

Tobin Surveys, Inc., San Antonio, Texas

University Art Museum, University of Minnesota, Minneapolis, Minnesota

University of Maine Museum of Art, Orono, Maine

University of Michigan Museum of Art, Ann Arbor, Michigan

Vanderwoude-Tananbaum Gallery, New York

Mr. and Mrs. Nathan Weisman

Whitney Museum of American Art, New York

Yale University Art Gallery, New Haven, Connecticut

and anonymous lenders

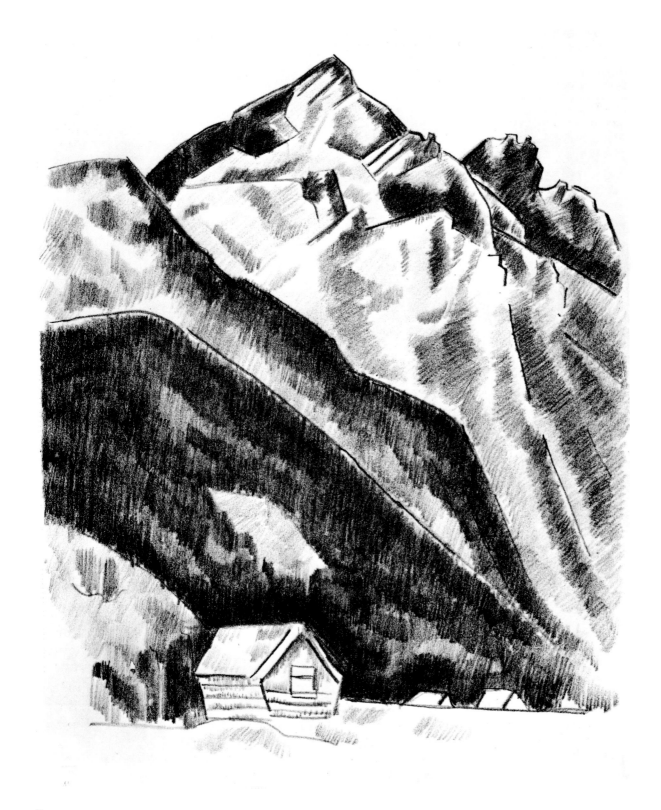

ACKNOWLEDGEMENTS

This exhibition is dedicated to James Taylor Dunn, '36, who provided the inspiration for it with his gift of Marsden Hartley's *Alpine Vista*, to the Hamilton College Collection in 1986. Mr. Dunn continues his support of art at Hamilton as an active member of the Committee on the Visual Arts. I am pleased to acknowledge his contribution as well as that of the other sixteen alumni and friends who comprise that group; I am particularly indebted to William G. Roehrick, '34 and D. Roger Howlett, '66.

I have had the honor of collaborating on this project with Gail Levin, Professor at Baruch College of the City University of New York, who in preparing the first catalogue raisonné of Marsden Hartley's work is establishing a new foundation for Hartley scholarship. She has contributed immeasurably to this exhibition by serving as guest curator and by allowing us to show and publish her own photographs of Hartley's Bavarian sites.

Sincere appreciation is extended to Larry Salander and Bill O'Reilly and the staff of Salander-O'Reilly Galleries, Inc., sponsor of the Hartley catalogue raisonné, for their interest and cooperation, especially to Emily Goldstein for her assistance in documenting Hartley's work of the Bavarian period. I also wish to acknowledge the other lenders to the exhibition who are individually credited, as well as those private lenders who chose to remain anonymous.

This exhibition would not have been possible without the financial support of the National Endowment for the Arts, Hamilton Friends of Art, and Albert A. and Vera G. List endowment; and the cooperation of the Collection of American Literature, Beinecke Rare Book and Manuscript Library, Yale University, and the Archives of American Art, Smithsonian Institution; and the directors and staffs of the other institutions who will participate in its tour, Milwaukee Art Museum, Bowdoin College Museum of Art, and Baruch College Gallery.

Cat. No. 18
Mountain Landscape [Alpspitze], 1933
Crayon on paper, 16 1/16 x 12 1/2 inches.
Collection, Yale University Art Gallery,
Gift of Walter Bareiss, B.S. 1940s

Warm appreciation is extended to Ruth Trovato, editor of this catalog; David Tewksbury for his photographic services; Grant Jacks for designing the publications that accompany this exhibition; and to my associates Wanda Denise Jackson and Katherine Le Grand-Reittinger, as well as the student workers, who comprise the staff of the Emerson Gallery.

Finally, I am deeply grateful to my wife, Marjorie, who shares my enthusiasm for the art of Marsden Hartley. Her support and patience have been typical and indispensable.

William Salzillo, Director
Emerson Gallery, Hamilton College

Research in Germany for this project was made possible by a grant from the American Council of Learned Societies. This exhibition would not have been possible without the sponsorship of a catalogue raisonné of Hartley's work by the Salander-O'Reilly Galleries, Inc., for which I wish to thank Larry Salander and Bill O'Reilly for their enthusiastic support. Emily Goldstein, research assistant and project coordinator on the catalogue raisonné, deserves special mention for her invaluable and diligent contribution. For initiating the exhibition and for his encouragement, I am grateful to Bill Salzillo of the Emerson Gallery, Hamilton College.

Gail Levin
Guest Curator

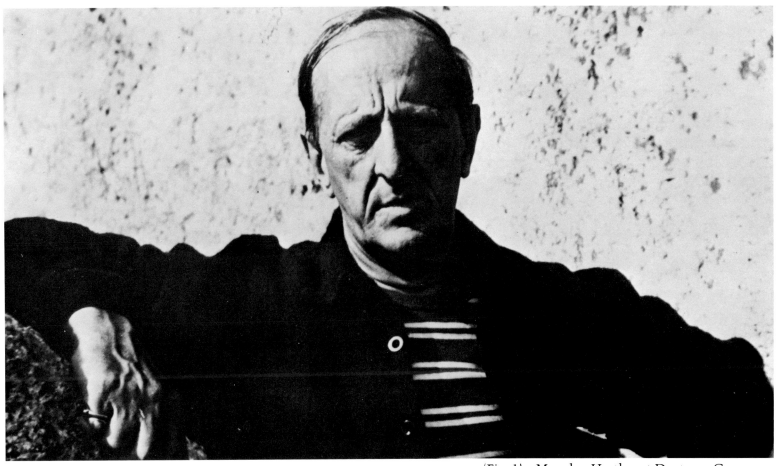

(Fig. 1) Marsden Hartley at Dogtown Common,
Cape Ann, Massachusetts, 1934

INTRODUCTION

William Salzillo

The work of Marsden Hartley's Bavarian period reveals aspects of his character and art that are often overlooked in discussions of his early symbolic abstractions or the late Nova Scotia and Maine paintings. The serenity of his alpine landscapes reflects the security that Hartley discovered in Garmisch-Partenkirchen, a sense of emotional comfort that enabled him to reconcile the poles of his aesthetic influences and the inner conflicts that often overwhelmed him. In 1933 Hartley was fifty-six years old, an embattled figure in search of spiritual and intellectual clarity. Relying on his powers of perception to capture the spiritual essence of the landscape that surrounded him, Hartley experienced a personal renaissance in Bavaria that laid the groundwork for his late style and the creative flowering of his last nine years.

Hartley's early success as a modernist innovator working in Paris and Berlin from 1912 to 1915 did not prepare him for the crisis in confidence he experienced during his middle period. His retreat

11

from abstraction after World War I left him without a theoretical basis for his art. Unable to succeed in his own half-hearted attempts to create an original style based on native American sources, Hartley returned to Europe in 1921. For the next ten years, he appeared to his friends to be directionless in both his life and art. In fact, he was engaged in a protracted reassessment of his artistic skills and sources of inspiration, a struggle to synthesize his Yankee heritage of transcendental romanticism with the techniques of European modernism to which he was committed.

Hartley's life in France during the twenties, first in Paris then in Vence and Aix-en-Provence, increasingly distanced him from his American audience. His Mont Sainte-Victoire landscapes, shown at the Intimate Gallery in New York in 1929, were rejected by the critics as obviously derivative of Cézanne. Encouraged by his dealer and mentor, Alfred Stieglitz, Hartley began to consider returning to America, as much to re-establish his business contacts as to secure his identity as a painter of his home state, Maine. In fact he did not actually arrive in Maine until 1937, his return prolonged by lengthy detours, first to Gloucester, Massachusetts, where he discovered Dogtown, then to Mexico, Bavaria and Nova Scotia. These stopovers, which prepared him for the psychological effort of going home, stand out as landmarks in the development of his late landscape style.

Hartley first visited Dogtown in 1920. He returned in 1931 to paint this ice-age moraine that embodied the primeval landscape described by T. S. Eliot in *The Waste Land*. Despite its surreal quality, which might have elicited the more fashionable iconography of the day, Hartley avoided falling back on his subjective imagination. As opposed to

a metamorphic style of landscape painting, his Dogtown pictures reveal an original point of view based on actual experience consistent with Hartley's pragmatic philosophy. By distancing himself from the analytical French tradition which had occupied him in the early twenties, Hartley achieved his first successful synthesis of Expressionism and Romanticism.

In the spring of 1931, Hartley received a Guggenheim fellowship that stipulated he work outside the country for one year. He chose to spend the time in Mexico, expecting to discover landscapes similar to those around Taos and Santa Fe, where he had painted in 1918-19. His trip began inauspiciously when Hart Crane, whom he had met soon after arriving in Mexico City, committed suicide by jumping from the steamship on which he was returning to the United States. Oppressed by the altitude and often sick, Hartley was unable to connect with the Mexican landscape. Instead he spent much of his time learning about Mayan and Aztec rituals and reading mystical texts borrowed from a friend's library. Less important to the formal development of his late landscape style than either the Dogtown or the Bavarian periods, Hartley's Mexican stay is nonetheless significant as a revival of his interest in the inner life — an interest which led to his greater cognizance of the power of symbols and new insights into the deeper meanings of the motifs he employed.

Seeking a respite after the intensity of his Mexican experience, Hartley traveled to Germany in 1933. He had felt an affinity for German culture since his first trip to Berlin in 1913. The German officer paintings, executed there, are still considered by many to be his greatest contribution to early modernism. Hartley saw the pre-war pageantry of Prussian militarism as an outward sign of

moral order, a European counterpart of the Yankee tradition. Throughout his life he remained blind to its darker side. He was also fascinated by the atmosphere of social decadence that surrounded Berlin and Hamburg in the twenties and thirties; the "divine decadence" celebrated by Christopher Isherwood[1] providing the opportunities he needed to explore his sexual nature. Despite his ambivalence about racial and political issues, he maintained an admirable ethical balance. Perhaps this was because he conceived of himself as a natural mystic who ascribed to archaic values that predate the social conventions imposed by modern society.

Because of his many friends among the German avant-garde and the fact that his reputation still meant something there, Hartley's return to Germany in 1933 was an especially pleasant homecoming. It was the mountain landscape of Bavaria, however, which sparked the combustion of creativity he experienced throughout the fall and winter of 1933-34. The village of Garmisch-Partenkirchen became Germany's top alpine resort after hosting the Winter Olympics of 1936, but when Hartley arrived in 1933, it still retained much of its primitive charm. Surrounded by the Wetterstein Range, including Germany's tallest peak, the Zugspitze, the low-lying town and its environs offer some of the most exciting views in Bavaria.

Mexico had stimulated his interest in mystical experience, intensifying his efforts to perceive the spiritual essence behind outward appearances. Following in the footsteps of the transcendentalists, he attempted to seek God in nature, and by "perfect observation,"[2] create a motif that would assume the dimensions of a universal symbol. The other paintings of Hartley's middle years rarely reveal the level of insight he achieved in Bavaria. Such clarity is often more common in his writings of the period,

in which he confidently shifts from direct expression to poetic allusion in order to create metaphors that assume the weight of visual evidence.[3]

The mountain had been a central motif in Hartley's work since 1906 when he began a series of Post-Impressionist landscapes that first brought him to the attention of Alfred Stieglitz. Associated in his mind with early success and the potentially profitable regional identity that would revitalize his American career, the mountain motif became a personal icon, with Mt. Katahdin looming like the epicenter of his imagination. He had also painted numerous mountain landscapes in the South of France during 1927, but at that time he was unable to arrive at the level of perception he achieved during his Bavarian stay. In the Mont Sainte-Victoire paintings, Hartley himself rarely emerged except in his posture as a student of Cézanne's analytical method. His most successful works of that period are his elegant silverpoint landscapes that often better approximate his actual level of inspiration during those years. The importance of Hartley's experiments in the South of France, however, cannot be underestimated when discussing the Bavarian work and its relation to his late landscape style. By assimilating Cézanne's approach, he was able to intensify his powers of perception, and ultimately achieve the level of objective clarity he sought. Although Hartley's brushwork in the Bavarian paintings points to Expressionist sources, his compositional techniques, based on heavily sculpted masses and overlapping planes, reveal the continuing influence of Cubism. As such these paintings represent a synthesis similar to that which Barbara Haskell has described in relation to the Berlin series of 1913-14, except that in this case it is arrived at by means of a newly-discovered landscape vision.[4]

In 1923, Hartley had traveled to Italy where he first encountered the work of Piero della Francesca. He was impressed by the metaphysical weight of Piero's art, a product of his aptitude for delineating mass which elevated the ordinary to the sublime. Hartley also admired the timeless stillness of Egyptian sculpture which he attributed to the artist's capacity to identify with his subject. With bold contours and simplified masses, Hartley's 1931 Dogtown series contained a similar feeling for weight, but it was not until 1933-34 that he was able to clarify this aspect of his vision. In time it became the hallmark of his art and the essential quality that emanates from his last great landscape and figure paintings.

The percipience achieved by Hartley in his Bavarian paintings, is attributable in part to a unique psychological identification with his subject. Throughout his life, Hartley sought spiritual mentors among older artists such as Ryder and Stieglitz, or historical figures such as Cézanne. In Bavaria, however, Hartley found a natural metaphor for age and wisdom; one that, without the generational perspective provided by family life, he was unable to discover in his own experience. The image of stability in Hartley's Bavarian mountain portraits is as much the achievement of mature artistry as it is the expression of inner need.

The high level of consciousness that Hartley began to experience in Garmisch-Partenkirchen continued in Nova Scotia and Maine. By reestablishing a connection with his Yankee heritage through a renewal of interest in Ryder, he became a great painter of the sea. In Nova Scotia, he found a semblance of family life that he had not experienced since he was a child. It led him to celebrate, in a lyrical style that harked back to American folk painting, the simple virtues associated with his working class background. Hartley's late figure paintings, with their powerful religious overtones, achieve a level of emotional intensity unique in American art.

In addition to illuminating the influences on Hartley's Bavarian period and its significance to his later landscape paintings, this exhibition provides an opportunity to reassess his role as a draftsman. Early in his career, he had followed in the steps of the Impressionists by painting directly from nature. By the mid-twenties, however, he had adopted a practice of sketching *in situ*, executing studies that he would later translate into finished works in the studio. He followed this pattern throughout the last years of his life when even drawing from nature became more a contemplative exercise than an activity that produced physical evidence. Hartley's early academic training at the Cleveland School of Art and the Chase School in New York had emphasized the importance of preserving the freshness of initial impressions. The simplicity and directness of his drawing technique during the Bavarian period represent a Whistlerian approach to capturing the mood of nature which contrasts with the later, more expressive style of his 1934-36 Dogtown sketches. Their emphasis on contour, however, derives from Post-Impressionism and, like Matisse and Kandinsky, Hartley manages to achieve maximum weight by means of minimal linear and tonal statements. The calligraphic directness of his Bavarian drawings is reminiscent of musical notation; resembling musical notation it exists to provide directions for subsequent performance. Hartley's drawing technique freed him from intellectuality, a necessary step on the way to achieving "perfect observation."

In mid-February, 1934, Hartley left Garmisch-Partenkirchen and returned to New York. Oblivi-

ous to the practical consequences of his acts, he had always been guided by the spiritual requirements of his art. He should not have been surprised, therefore, when Stieglitz initially declined to exhibit his Bavarian paintings.[5] European images had become increasingly unsaleable in a market dominated by Regionalism. Stieglitz himself had retreated from supporting intuitive abstraction to become a spokesman for an art based on indigenous American sources. By 1935, Hitler's expansionist and anti-Semitic policies had resulted in general distrust of all things German, especially among Hartley's Jewish friends such as Ettie Stettheimer, who was vigorously opposed to his subject matter during this period.[6]

Throughout the last nine years of his life, Hartley continued to be haunted by bad health and economic problems, but his Bavarian stay provided a reservoir of creative inspiration that supported him even in moments of despair. By helping reassert confidence in his artistic mission, it remained the eye of an emotional storm that nearly engulfed him in Nova Scotia and continued to rage until 1941 when his joint exhibition with Stuart Davis at the Cincinnati Art Museum signaled growing critical acceptance of his work and the possibility of financial security. Unfortunately, Hartley did not live long enough to enjoy the profits of his labors. He died in Ellsworth, Maine on September 2, 1943.

Although he passed beyond the coolness of his Bavarian landscapes, their importance to him was revealed in 1939, when he finally made the journey to Mt. Katahdin. He wrote, "I have achieved the 'sacred' pilgrimage to Ktaadn [sic]. I feel as if I had seen God for the first time...."[7] □

NOTES

1. For a classic literary reminiscence of German society in the thirties, see Christopher Isherwood, *The Berlin Stories* (New York: New Directions Publishing Corporation, 1963).

2. Marsden Hartley to Adelaide Kuntz, letter of December 12, 1933, Archives of American Art, Smithsonian Institution, Washington, D. C., roll X 4; the original in the Collection of American Literature, Beinecke Rare Book and Manuscript Library, Yale University, New Haven, Connecticut [hereafter cited as AAA and Yale].

3. To learn more about Hartley's writing, see Gail R. Scott, ed., *On Art by Marsden Hartley* (New York: Horizon Press, 1982).

4. Barbara Haskell, *Marsden Hartley* (New York: Whitney Museum of American Art in association with New York University Press, 1980), p. 33.

5. Seven of the Bavarian paintings were later included in the exhibition. "Marsden Hartley," at An American Place (March 22 – April 14, 1936).

6. Haskell, *Marsden Hartley*, p. 96.

7. Marsden Hartley to Adelaide Kuntz, letter of February 2, 1940, AAA and Yale. Ktaadn is the Indian spelling of Katahdin.

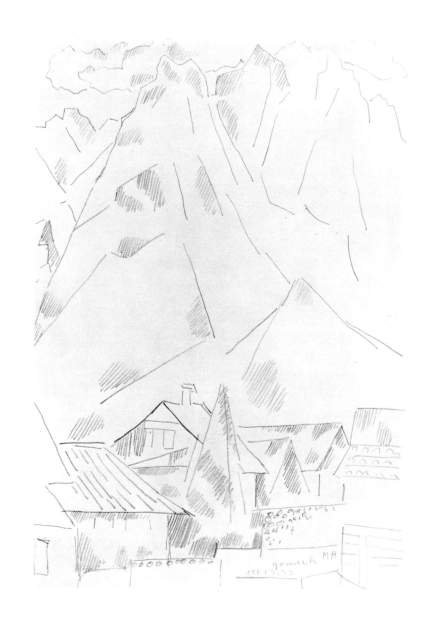

Cat. No. 44
Garmisch, October 13, 1933
Pencil on beige paper, 9 7/8 x 7 inches.
Courtesy, Marsden Hartley Memorial
Collection, Museum of Art, Olin Arts Center,
Bates College, Lewiston, Maine

MARSDEN HARTLEY IN BAVARIA

Gail Levin

Marsden Hartley (1877-1943), the painter, poet, and essayist who distinguished himself as one of America's pioneer modernists, began to evolve his last great landscape style in the Bavarian alpine village of Garmisch-Partenkirchen during the autumn and winter of 1933-34. In May 1933, Hartley had returned to Germany for the first time since 1930, having spent a year in Mexico, during which time he lived on a Guggenheim Foundation fellowship. At the time, he was still deeply interested in esoteric mystical texts and these writings are reflected in the colorful, yet eccentric paintings he had produced in Mexico.

Hartley spent the spring and summer of 1933 in Hamburg, before traveling south to Garmisch-Partenkirchen, in the heart of the German Alps, in September. After the expiration of his fellowship, he was once again struggling financially, so that the lower cost of living away from urban life must have appealed to him. Beyond this, the similarity of the Bavarian Alps to the mountains in his native Maine must have attracted him.

Hartley had first visited Bavaria in January 1913, when, after a three-week trip to Berlin, he stopped off in Munich and met several of the avant-garde painters of Der Blaue Reiter, including Franz Marc (1880-1916), Wassily Kandinsky (1866-1944), and Gabriele Münter (1877-1962). During his 1933-34 stay in Bavaria, Hartley fondly recalled spending a weekend in Sindelsdorf in the Alps in the spring of 1913 with Franz Marc, when they walked the two miles from the

station to the German artist's home, enjoying the flowers and greeting Bavarian children with the local expression, "Grüss Gott," meaning "God greets you."[1]

For his 1933-34 sojourn in Bavaria, Hartley lived in a boarding house, the Landhaus Schober (figure no. 2), in Partenkirchen at Triftstrasse 4. From his window, he could see a mountain view, which Herr Schober assured him was "very grand" from the Austrian side as well, just twenty-seven kilometers from Partenkirchen.[2] Even the name "Triftstrasse," suggests memories of Maine, for it means "floating street," deriving from past logging industry practices, when a complex system brought timber down from the mountains through exploiting the tossing icy waters of the Partnach Gorge.

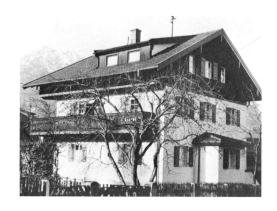

Hartley enjoyed the spectacular alpine scenery surrounding Partenkirchen and participated enthusiastically in the Bavarian pastime of walking through the mountain landscape. During the first eight weeks, he made many excursions when he sketched the scenery, bringing back motifs to paint in his room. On September 7, 1933, he wrote to a friend that he had "had five days of alpining which has been heavenly — O God so comforting to get next to rocks & earth again — and there can be no single form more glorious in all the Alps than these are — the Waxenstein alone would start another school of Chinese painting."[3] Hartley explained that Chinese artists understood the mountain "more than any other artists — the meaning of space the significance of rhythm and the quality of time in appearances...."[4]

When he wrote to his niece on September 30, Hartley complained: "The Alps are cloudy these several days but I must walk and talk with them just the same — They help me 'in time of trouble.' It's a bit lonely for I have nobody 'to play with.'"[5] This sense of isolation that so pained Hartley was in contrast to the company he had found among the American expatriate artists and writers he had encountered in Mexico. They included Paul Strand, Andrew Dasburg, Hart Crane, and Mark Tobey. The latter two, like Hartley, were homosexual, offering him a special rapport. Tobey also shared Hartley's fascination with esoteric religious ideas.[6]

(Fig. 2) Haus Schober, Garmisch-Partenkirchen

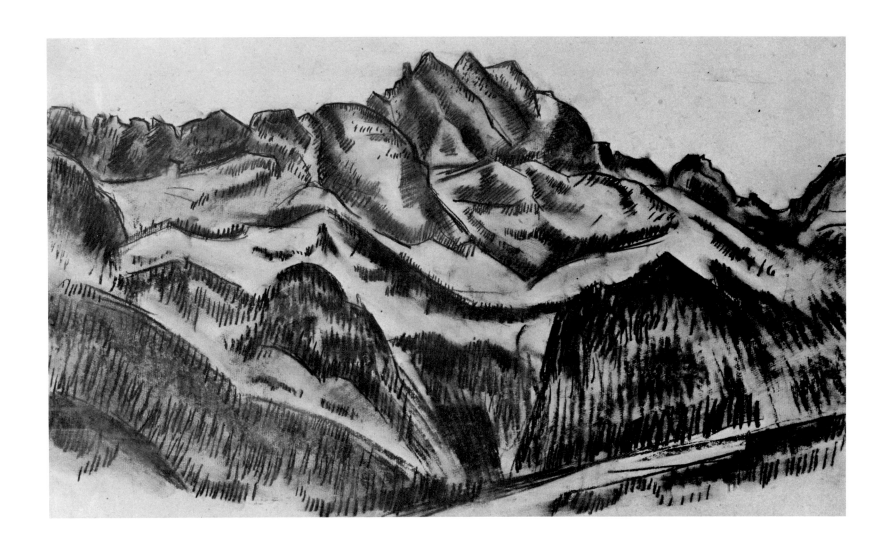

Cat. No. 23
Dreitorspitze from Gschwandtnerbauer,
1933
Charcoal on cardboard, 18 x 29 3/4 inches.
Collection, Tobin Surveys, Inc.

Newly arrived in Bavaria, Hartley had to rely entirely upon himself. Nearly fifty-seven years old, he nonetheless made a rigorous daily schedule for himself with some challenging hikes. Hartley had a life-long predilection for seeking out remote locales as his subjects. He had also been drawn to mountains since his youth. In 1908, he had painted mountains near North Lovell, Maine, in a Neo-Impressionist style. In 1919, he painted mountains around Santa Fe, New Mexico. Painting mountains in southern France during the late 1920s, Hartley focused on Mont Sainte-Victoire in homage to Cézanne. In New Hampshire in 1930, Hartley once again found mountains to paint. In Mexico, Hartley's dramatic views of mountains included the volcano, Popocatepetl.

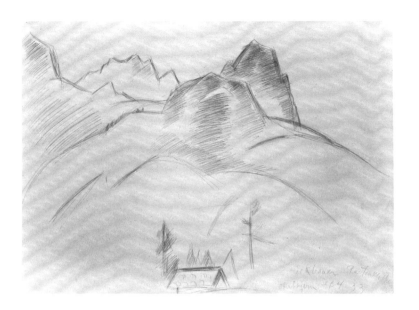

A Bavarian sketchbook reveals the fruits of Hartley's solitary walks around Garmisch-Partenkirchen and suggests the motifs of the paintings which would follow. On the fourth and fifth of September, he climbed up 4,127 feet to the Eckbauer, sketching the Gasthof there and the views, including the higher peak of Karwendel and a view of Waxenstein (cat. nos. 63, 64, 66 and 67). On the tenth of September, he sketched both Waxenstein peaks (known as Kleiner and Grosser). Then on September 11, walking in the other direction, down the Triftstrasse, he sketched another view of the twin Waxenstein peaks (cat. no. 70). Two days later, Hartley sketched the Zugspitze several times and the two Waxensteins from Garmisch (cat. nos. 71 and 74). On the sixteenth of the month, he again recorded Waxenstein in a sketch entitled, *From Riesersee Waxenstein toward Höllen Tal Klamm* (cat. no. 75). He also sketched Waxenstein, a favorite motif, from vantage point of the Pflegersee. By October 7, Hartley had discovered Gschwandtnerbauer under Wank peak, where he sketched Karwendel, Dreitorspitze, and a church in a distant mountain village.

In addition to his wanderings, Hartley came to appreciate "these Alps that stand so gloriously out of my window capped in snow now for the rest of the year...."[7] He also found the life in the small town

◄
Cat. No. 63
Mountain Landscape, House in Foreground, 1933
Inscribed lower right: *Eckbauer Partenkirchen Oberbayern Sep 4 33*
Silverpoint on paper, 10 5/8 x 14 7/8 inches.
Courtesy, Babcock Galleries

▲
Cat. No. 64
Mountain Landscape, 1933
Inscribed lower right: *From Eckbauer, Oberbayern above Partenkirchen Sep 4 33*
Silverpoint on paper, 10 5/8 x 14 7/8 inches.
Courtesy, Babcock Galleries

20

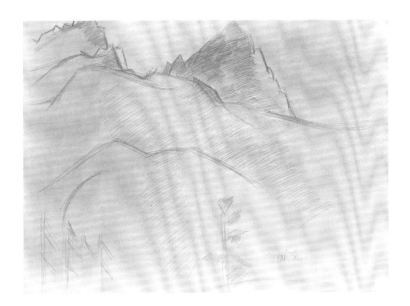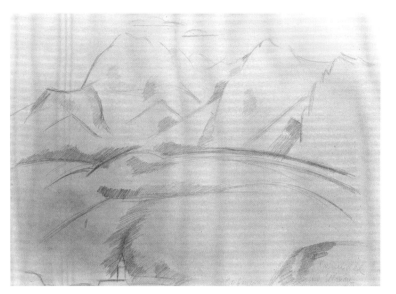

▲
Cat. No. 66
Mountain Landscape with Pine Trees,
1933
Inscribed lower right: *Waxenstein Sep 4 33*
Silverpoint on paper, 10 5/8 x 14 7/8 inches.
Courtesy, Babcock Galleries

▶
Cat. No. 67
Mountain Landscape, Church Steeple in Foreground, 1933
Inscribed lower right: *Oberbayern, Karwendel und Ellmau Sep 5 33*
Silverpoint on paper, 10 5/8 x 14 7/8 inches.
Courtesy, Babcock Galleries

very agreeable. To his niece, he exclaimed: "I love village life of this sort where animals have just as much privilege as the people and so you will see a line of cows going up through the main street of Parten Kirchen or a load of manure—sweet smelling after city odours...."[8] Even today, this charming aspect of Partenkirchen is still evident, as cows occasionally amble down the main streets calling a sudden halt to local automobile traffic.

Hartley captured the beauty of the local landscape in the paintings, drawings, pastels, and lithographs that he produced of the Bavarian countryside. In addition to the dramatic grandeur of the Alps, he also recorded some of the picturesque local color through his inclusion of characteristic examples of regional architecture. Most frequently, the only architecture visible in Hartley's Bavarian paintings are the small, low A-frame wood sheds built of logs that dot the fields in the countryside around Garmisch-Partenkirchen. Yet, he also painted the mountain Gasthof or guest house on Eckbauer and the rural mountain church visible across the valley from Gschwandtnerbauer (cat. no. 27).

21

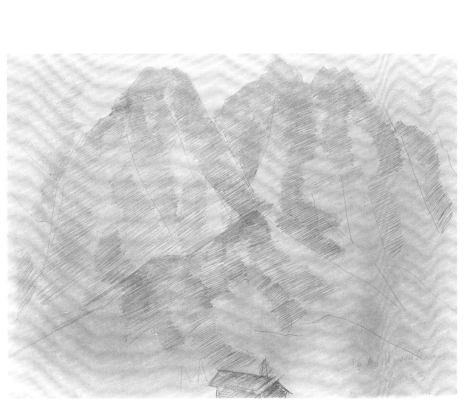

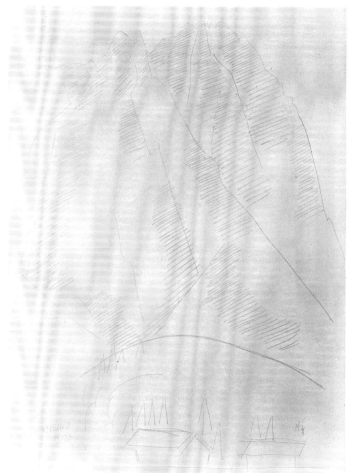

◄
Cat. No. 70
Mountain Landscape, with Building in Foreground, 1933
Inscribed lower right: *The Two Waxensteins Sep 11 33*
Silverpoint on paper, 10 5/8 x 14 7/8 inches.
Courtesy, Babcock Galleries

▲
Cat. No. 74
Mountain Landscape, Two Buildings in Foreground, 1933
Inscribed lower left: *Waxenstein Sep 13 33*
Silverpoint on paper, 14 7/8 x 10 5/8 inches.
Courtesy, Babcock Galleries

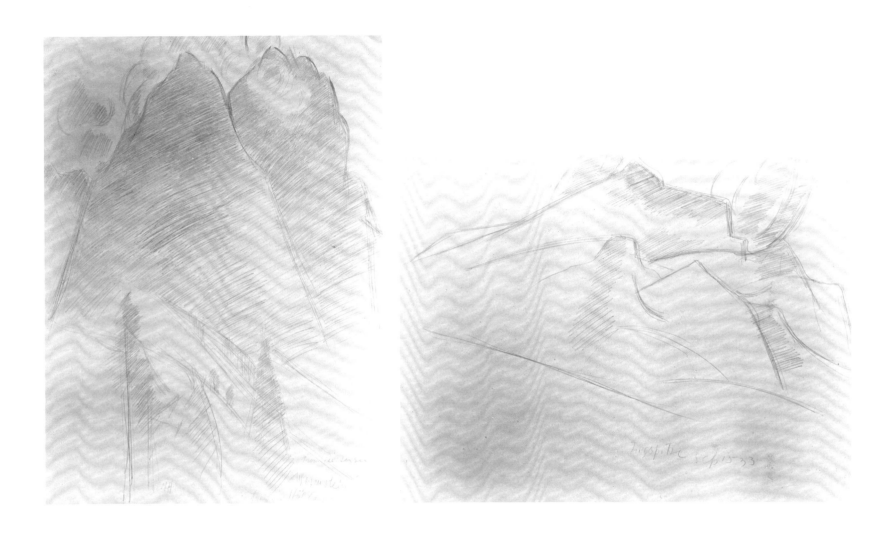

▲
Cat. No. 75
*Mountain Landscape, Twin Peaks, Trees
in Foreground*, 1933
Inscribed lower right: *From Riesersee
Waxenstein toward Höllentalklamm
Sep 16 33*
Silverpoint on paper, 14 7/8 x 10 5/8 inches.
Courtesy, Babcock Galleries

▶
Cat. No. 71
Mountain Landscape, 1933
Inscribed lower right: *Zugspitze Sep 13-33*
Silverpoint on paper, 10 5/8 x 14 7/8 inches.
Courtesy, Babcock Galleries

Besides the landscape itself, Hartley drew inspiration from the art that he saw in Germany. On November 12, he was in Munich and, while there, visited the Alte Pinakothek. He reported to his niece: "I went to the museum yesterday only because it is my language and it is well every now and then to give a good sweep over a museum just to recall the different ways of speaking the language, and there is never a time when you don't get some new point of view from old things."[9] He was most enthusiastic about Albrecht Dürer's *Self-Portrait*, painted in 1500 (figure no. 3), exclaiming: "it is the all around best portrait that has ever been done by anyone at any time...Dürer seemed to have all that the eye can have, he saw things exactly as they were, and knew how to convey that impression...I would like to make a painting of a mountain and have it have all that this portrait has."[10]

During his visits to the Alte Pinakothek in Munich, Hartley was also quite impressed by Leonardo da Vinci's *Madonna with a Carnation*, painted about 1475 (figure no. 4). Several years later, in 1939, Hartley wrote an essay on this painting, which he recalled he had seen several times, remarking of the Madonna that "it is as if the crisp mountains in the distance send toward her their glacial recognition."[11] Examining this painting, we can have no doubt that, in 1933, Hartley would have been fascinated with Leonardo's depiction of the alpine mountain landscape in the painting's background, visible in the distance, dramatically framed by double arcades. Hartley described the landscape "out of the window as one of the best pieces of mystical landscape ever done by anyone..."[12] and referred to the landscape in a later essay as:

> those strange mountains out of the four round-arched
> windows, the kind of vista out of which little but discom-
> fort can come since one cannot learn exactly what the
> place is, among whose valleys and crevices flood, tornado,
> the sudden pressure of glaciers all ominous and forebod-
> ing, where the imagination functions stronger than any-
> where else in the picture, as if to represent the fatigue of
> the world in the attempt to struggle with the divine idea,
> that strange austere wisdom which seems always to reside
> in the appearances of nature, and probably because we

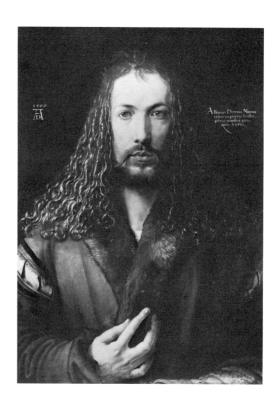

(Fig. 3) Albrecht Dürer, *Self-Portrait*,
1500. Oil, 67 x 49 cm,
Alte Pinakothek, Munich

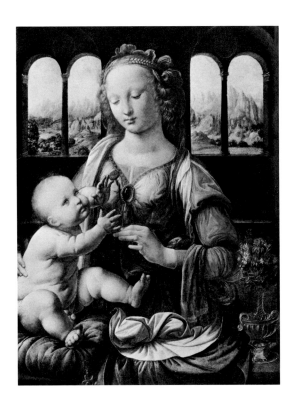

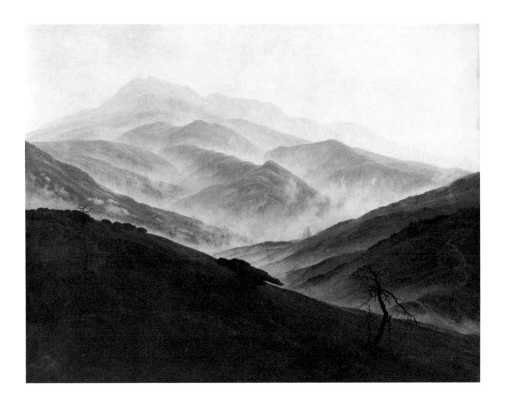

ourselves being foolish, all things else in nature look more intelligent than we because they act so, those strange appearances that come to the surface at times as if to terrify the world into a state of recognition.[13]

Hartley's rambling prose does offer insight into his own rapport with the landscape; he drew emotional sustenance from his direct interaction with nature. He was also intensely concerned with the specificity of the landscape he painted. He did not just paint generalized mountains, but wanted, indeed, to paint his mountains the way Dürer painted the expressive realism of his *Self-Portrait*. This explains Hartley's predilection for hiking such distances to seek out his particular landscape subjects. He would enthusiastically walk as far as seven miles with his sketching materials in tow, because he so earnestly wanted to convey the exactness or individuality of each site he painted.

▲
(Fig. 4) Leonardo da Vinci, *Madonna with a Carnation*, c. 1475. Oil, 62 x 47.5 cm. Alte Pinakothek, Munich.

▶
(Fig. 5) Caspar David Friedrich, *Mountain with Rising Fog*, 1810. Oil on canvas, 54.9 x 70.3 cm. Neue Pinakothek, Munich.

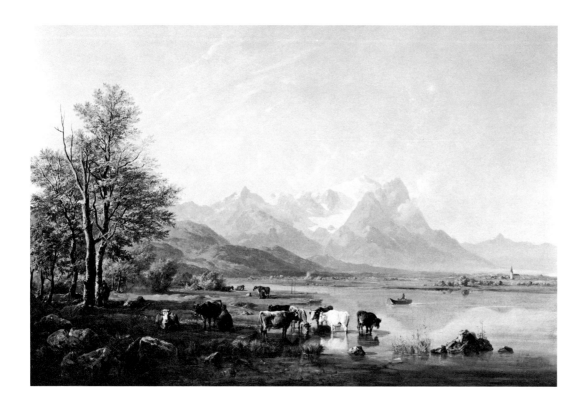

Hartley explained his philosophy behind his working method: "It is not exactly easy plowing up & down these heights to get at the subjects I am interested in — and all I can do is make drawings chiefly skeleton — to fix my eyes on the profile aspects of it all and the rest will have to be done inside...."[14] Hartley got to know the "forms" of the mountains he painted by looking at their masses from a distance and by climbing them. He longed to paint Mt. Katahdin in northern Maine, but lamented that he could not afford even the minimum price of living there.[15] For Hartley, the local mountains spoke his language: "it is my country & it didn't take me long to find that out."[16]

Hartley also looked at the near-by collection of nineteenth-century painting at the Neue Pinakothek in Munich which contained examples of German artists' earlier responses to the same Bavarian landscape he was then attempting to paint. He would have seen the work of German Romantic landscapists like Casper David Friedrich (1774-1840) whose *Mountain with Rising Fog* of 1810 (figure no. 5), for

(Fig. 7) Heinrich Bürkel, *By Garmisch with a View of Zugspitze*, 1839. Oil, 59 x 88 cm. Städtishe Galerie im Lenbachhaus, Munich.

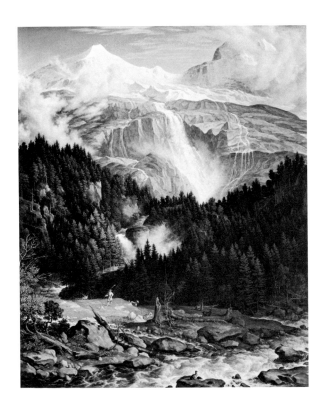

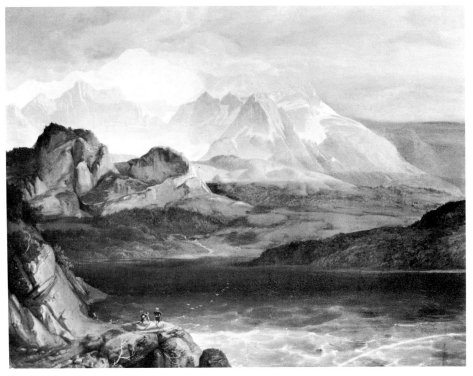

example, reveals the artist's deep empathy with the forces of nature. As in Friedrich's painting, Hartley, himself, was developing a strong interest in conveying the emotional effects of nature. In contrast, the more traditional landscapes like Joseph Anton Koch's *Der Schmadribachfall* of 1821/22 (figure no. 6), demonstrated to Hartley the dangers of too much adherence to literal details.

Earlier views of Garmisch-Partenkirchen were produced by German painters like Heinrich Bürkel (1802-69) and Karl Rottmann (1798-1850). Bürkel's *By Garmisch with a View of Zugspitze* of 1839 (figure no. 7) employs the tedious detail of painters like Koch. Yet Rottmann's *The Eibsee by Partenkirchen* (figure no. 8), has more of the poetry of Friedrich's landscapes. Hartley's views of Garmisch-Partenkirchen develop this earlier poetic rendition of nature into a much bolder and straightforward simplification of forms, perhaps only possible after the initial experiments of early twentieth-century modernism.

▲
(Fig. 6) Joseph Anton Koch,
Der Schmadribachfall, 1821/22.
Oil on canvas, 131.8 x 110 cm.
Neue Pinakothek, Munich.

▶
(Fig. 8) Karl Rottmann, *The Eibsee by Partenkirchen*, 1825.
Oil on canvas, 76 x 100 cm.
Neue Pinakothek, Munich.

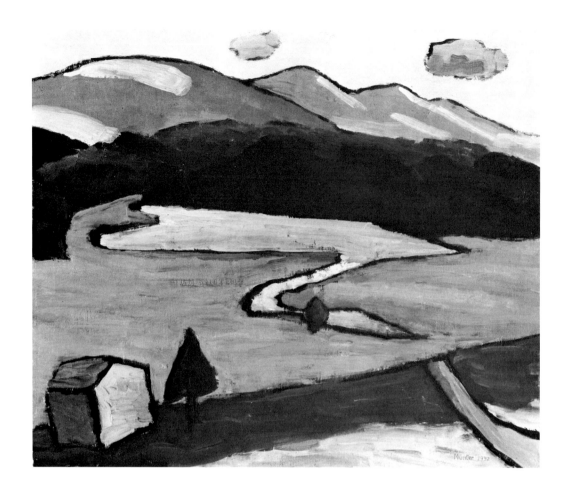

In addition to his encounter with modern art in New York in the coterie of Alfred Stieglitz and his gallery known as "291," Hartley had a firsthand acquaintance with School of Paris art including the work of Matisse, Picasso, and Delaunay, from the Parisian circle of the American expatriate, Gertrude Stein. Then, from 1913, he had spent time in Germany, visiting galleries and meeting artists, familiarizing himself with the avant-garde. His Bavarian landscapes can be understood in relationship to work by some of the German contemporary artists that Hartley first encountered in 1913.[17]

Hartley did not actively pursue his desire to visit his old acquaintances among the avant-garde German art circles. By April 1933, just before Hartley arrived in Hamburg, Kandinsky, who had left Bavaria to return to his native Russia in late 1914 and had returned to

(Fig. 9) Gabriele Münter, *Der Graue See*, 1932. Oil, 54.8 x 65.7 cm. Städtishe Galerie im Lenbachhaus, Munich.

28

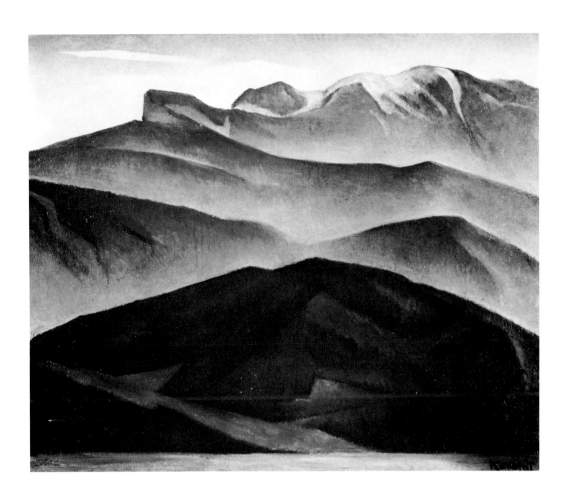

Germany in December 1921, was subjected in Berlin to the Nazis' closing of the Bauhaus, the renowned school of art and design where he had taught since 1922.[18] That December, Kandinsky arranged to move to Neuilly-sur-Seine, near Paris, and left Germany for the last time. Evidently, Hartley was not fully aware of Kandinsky's or Paul Klee's (1879-1940) fate under the Nazis, when, on November 15, 1933, he wrote to a friend: "Kandinsky and Klee are now living in Berlin, so it is still Berlin that would give me some life...."[19] Two of the other important avant-garde artists whom Hartley had met on his first visits to Germany, Marc and August Macke (1887-1914), were dead. Hartley wrote "Marc was killed in the war and a fine German spirit was removed" and that he wished he could find Marc's wife in order to talk of him and get a photo of him: "I think of him here — so often — for he lived at Sindelsdorf."[20]

(Fig. 10) Alexander Kanoldt,
Kreuzjoch, 1931.
Oil, 62 x 75 cm.
Städtishe Galerie im
Lenbachhaus, Munich.

29

Kandinsky's former companion, Gabriele Münter, however, was still living and painting in the Bavarian town of Murnau. Her landscapes continued to present a simplified and lyrical response to her surroundings. The bold, simplified shapes of her 1932 painting, *Der Graue See* (figure no. 9), for example, reveal a sensibility to which Hartley must have responded, although her palette was much brighter than that he chose for his own Bavarian landscapes.

Alexander Kanoldt (1881-1939) who had remained in the New Artists Association when the more radical painters, including Kandinsky, Marc, and Münter, left to form Der Blaue Reiter, also continued to paint the German landscape. Although during the 1920s, Kanoldt came to be associated with the Neue Sachlichkeit (new objectivity) painters, his landscapes also reflected the classical training of his father, Edmund, a landscape painter who trained with Friedrich Preller (1804-1879), an artist close to both Karl Rottmann and Joseph Anton Koch (1768-1839). Alexander Kanoldt's *Kreuzjoch*, a view of

▲
Cat. No. 55
Höllen Tal Klamm, 1933
Pencil on paper, 6 3/4 x 9 3/4 inches.
Collection, Victoria Miller, Alexandria, Virginia

▶
Cat. No. 19
Garmisch-Partenkirchen [Alpspitze], 1933
Lithographic crayon on tracing paper, 13 3/16 x 9 15/16 inches.
Courtesy, University Art Museum, University of Minnesota, Minneapolis. Bequest of Hudson Walker from the Ione and Hudson Walker Collection.

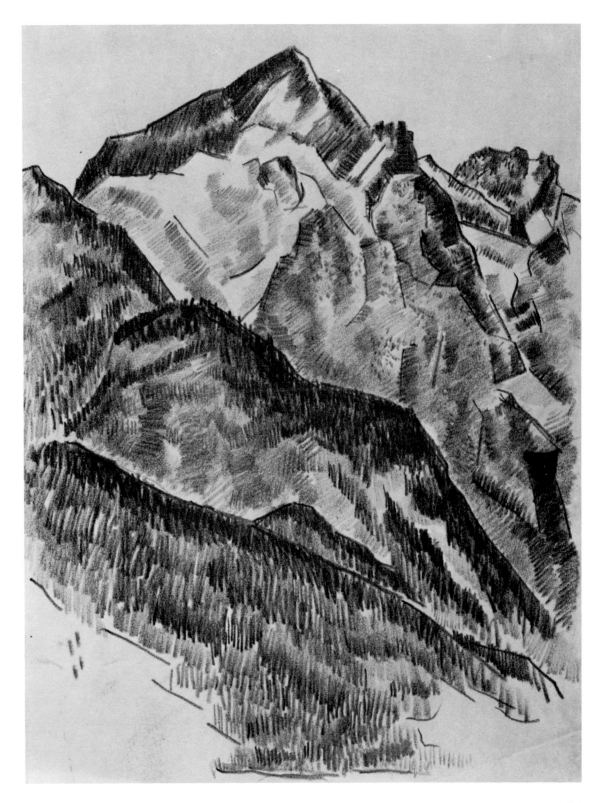

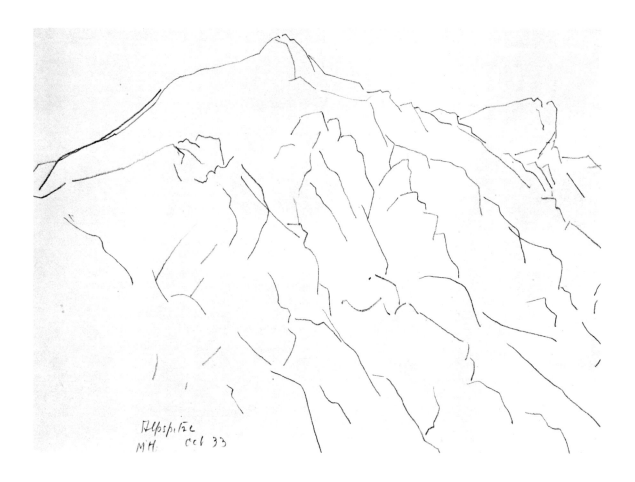

mountains painted in 1931 (figure no. 10), is similar to the approach Hartley was to take in his paintings of the Bavarian landscape in both its simplified composition and its subdued palette.

By November 27, Hartley wrote to his niece that "it is snowing a lot and I am painting Alpine snow effects indoors. I walk six or seven miles and make the drawing and the rest is memory — but I have had to work that way for years and it is my way of showing how much I have learned and absorbed from nature."[21] He reported that he had six paintings underway and that "they look quite intelligent. The world is very handsome here now with snow on everything — that is on the upper hills and Alps — it stays up there because it is cold but melts off in the valley...."[22] Hartley was reasonably pleased with his own efforts at painting the Alps which he thought he would call "portraits":

Cat. No. 42
Alpspitze, October 11, 1933
Pencil on paper, 7 x 9 1/2 inches.
Collection, Mr. Gerald Ferguson

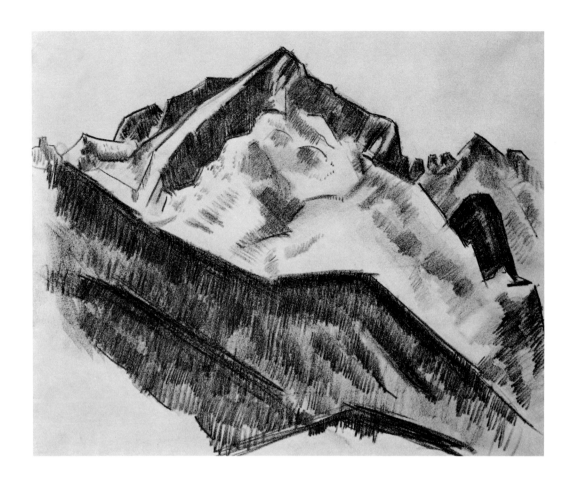

I have at last registered some Alps and they look most Alpish which is of course what I want them to do, but they are not like anything that the common world would think of as Alps, because these Alps themselves, that is the few usable motives are the most original I have ever seen, and I have I know, gotten them as they are, and with as close a fidelity as the eye is capable of and not use a camera, even a camera cannot get the inner effect of them, but all I wished I have put in these new ones for what I wanted to get is their inner character, and still have them look "natural" so that the peasant would say at once O yes that is the Waxenstein, and, that is the Alpspitz, and know the difference when he is looking.[23]

Cat. No. 20
Mountains [Alpspitze], 1933
Charcoal on paper, 12 3/8 x 15 3/4 inches.
Permanent Collection of the High Museum
of Art, Atlanta, Georgia

Hartley was working rather frenetically; by December 18, he reported that he had ten pictures "under way or finished."[24] By the end

of the month, he noted: "I just realized that I had been working very hard — nearly finished 15 pictures in 7 weeks and walked over 100 miles to make drawings and observations — and painting is always an intense matter with me — so I knocked off to regain myself."[25]

On January 4, 1934, Hartley spent his fifty-seventh birthday in Munich, uncharacteristically splurging by treating himself to good food. During his stay there, he also reported that he visited four museums:

> My greatest pleasure was the Alpine Museum there which is a remarkable institution, and like everything else German very thorough and complete, and you see there all the mountains of the world, and learn of all the history of mountain climbing from early Roman times...I learned incidentally all about my Alps here and I know now just how they look from the other side of what I have here, for the models are large and very complete.[26]

▲
Cat. No. 53
Waxenstein, 1933
Graphite on paper, 5 3/16 x 7 3/4 inches.
Collection, Roald and Susan Nasgaard, Toronto

▶
Cat. No. 62
Waxenstein, October 29, 1933
Sepia ink on paper, 13 7/8 x 10 3/8 inches.
Courtesy, Babcock Galleries

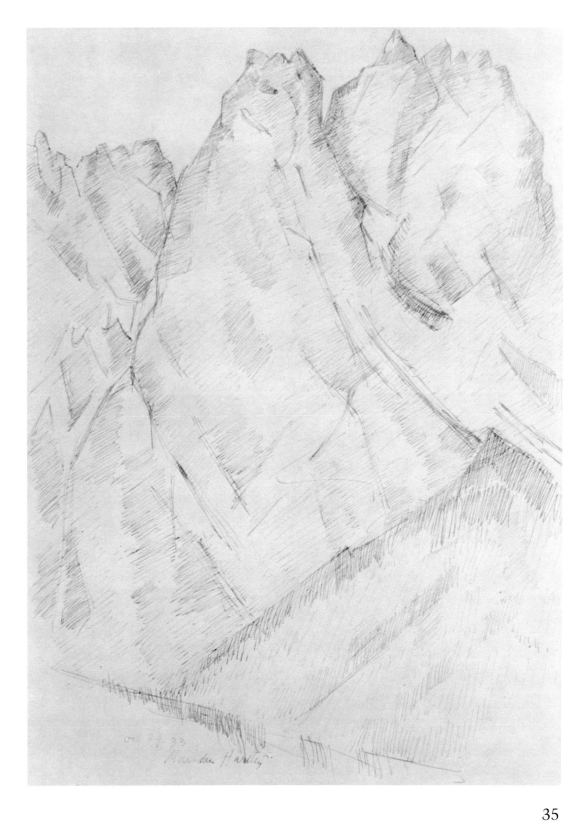

35

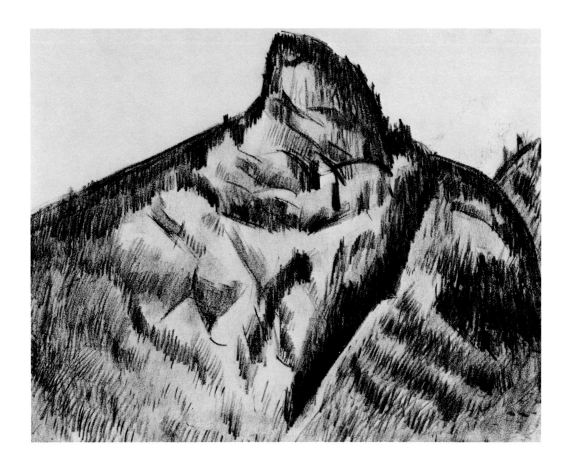

Hartley longed to go on to St. Moritz in Switzerland, where Giovanni Segantini (1858-1899), whose Post-Impressionist paintings of mountains he had studied in reproduction when he first painted mountains in Maine, had worked. He also admired the mountain landscapes of another Swiss artist, Ferdinand Hodler (1853-1918). He described Segantini and Hodler as "the only two who really understood mountains as applied to art."[27] Only his lack of money and the high cost of living in Switzerland kept the peripatetic Hartley from making the journey. Having seen one of Segantini's paintings in the museum in Hamburg,[28] Hartley visited the Neue Pinakothek in Munich, for he reported to his niece that he had seen one of Segantini's paintings:

But there is in the museum in Munich one of his most famous pictures, and this I was able to see for the first time last week, and studied every inch of it and it is a huge canvas...Segantini

Cat. No. 34
The Mountain [Kofelberg, Oberammergau], 1934
Crayon on paper, 12 3/4 x 15 3/4 inches.
Collection, Lois Borgenicht

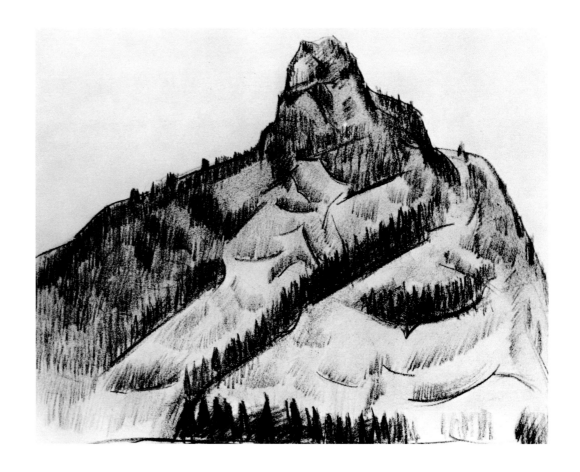

Cat. No. 36
Kofelberg, Oberammergau, 1934
Charcoal on tracing paper, 12 x 15 1/2 inches.
Collection, Mr. Edward Glannon

was...a marvellous painter, and as I say the only one who has ever understood the mountain and mountain light, for he poured his whole soul and mind into them....[29]

The painting Hartley admired so was Segantini's *Aratura* of 1890, a depiction of farmers plowing a field, acquired by the Munich museum just six years after it was painted.

In January, toward the end of his stay in Bavaria, Hartley finally got to visit the neighboring town of Oberammergau where every ten years a Passion play is staged. He traveled the twelve miles to Ober-ammergau by bus which took only an hour and found it to be "a very attractive place and has some very handsome mountains in back of it — of which I made drawings and will go once more to make larger ones for paintings."[30] Hartley did produce several drawings of the dramatic

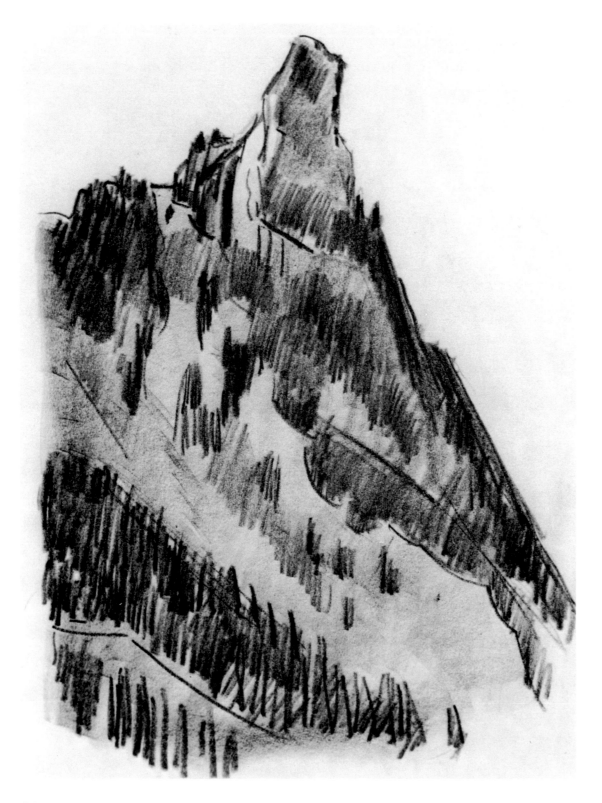

peak of Kofelberg in Oberammergau (cat. nos. 34, 35 and 36), but he evidently never got to paint the image. He did, however, produce a lithograph of this motif (cat. no. 40), one of four he made based on the Bavarian landscape. He also wrote about the peak in Oberammergau in one of his poems:

> The Kofel, Kofel—
> that's the mountain of this place,
> stands high above him in its state of
> grace,
> lean, with wisdom of a line,
> perfected form, in fine—[31]

Hartley continued to draw outdoors even during the cold snowy weather of February, exclaiming: "The walking is grand now of course because the Alps can be seen in all their glory now — and though I come in all but frozen to the gizzard trying to make drawings — it is exciting to be out in it."[32]

Characteristically, Hartley worked on several favorite alpine motifs, sketching and then painting them repeatedly or turning them into lithographs. He thought that he could sell his lithographs more easily than his paintings and planned to support himself from these sales.[33] His best-loved subject was clearly Alpspitze, except for the towering Zugspitze (cat. no. 54), the highest local peak. Though visible from many vantage points around Partenkirchen, Hartley preferred the views of Alpspitze from Gschwandtnerbauer, just up off the road to Mittenwald, a town of violin makers just eleven miles away to which Hartley once hiked.

The snow-covered views in the paintings entitled *Alpspitze, Mittenwald Road* (cat. nos. 1 to 4),were probably painted during the latter part of Hartley's stay in Germany. He also produced a lithograph of Alpspitze (cat. no. 37). The dramatic twin peaks of Waxenstein, which occur in several paintings, drawings, and in the lithograph, *Waxenstein* (cat. no. 39), offered Hartley another of his favorite subjects. Hartley's fourth Bavarian lithograph, *Dreitorspitze* (cat. no. 38), also records a view seen from Gschwandtnerbauer and repeats a vista of several paintings.

Cat. No. 54
Zugspitze, 1933
Pencil on paper, 15 3/8 x 11 5/8 inches.
Collection, Mr. and Mrs. David K. Anderson

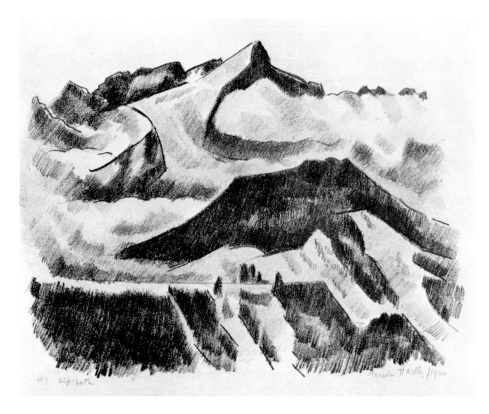

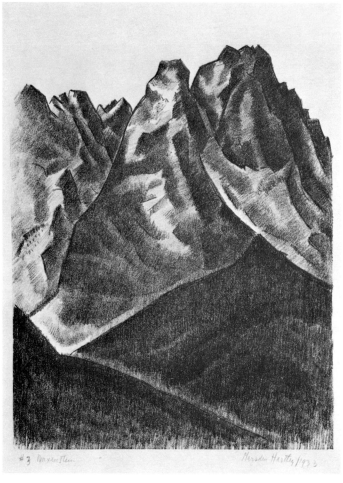

◄
Cat. No. 37
Alpspitze, 1933-34
Lithograph, 11 1/2 x 15 inches.
Courtesy, Oklahoma Art Center

▲
Cat. No. 39
Waxenstein, 1933-34
Lithograph, 15 7/8 x 12 inches.
Courtesy, The Art Museum, Princeton
University.
Gift of Carl Otto von Kienbusch for the Carl
Otto von Kienbusch, Jr. Memorial Art
Collection

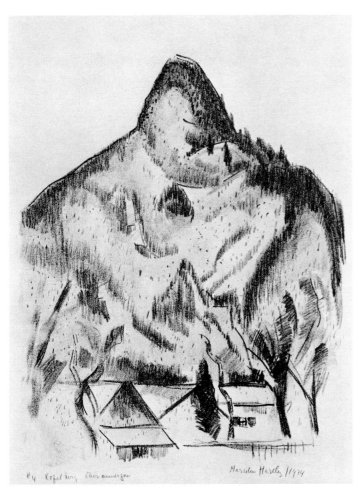

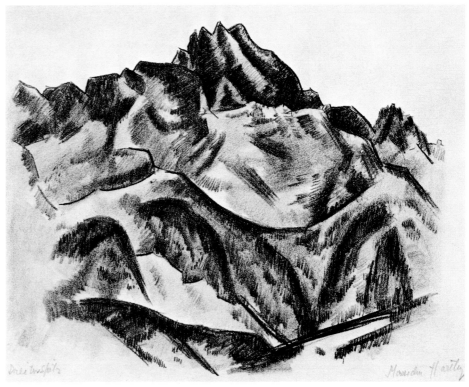

▲
Cat. No. 40
Kofelberg, Oberammergau, 1934
Lithograph, 15 1/2 x 12 1/2 inches.
Courtesy, University of Maine Museum of
Art

▶
Cat. No. 38
Dreitorspitze, 1933-34
Lithograph, 12 1/4 x 15 7/8 inches.
Courtesy, University Art Museum, University of Minnesota, Minneapolis. Gift of Ione
and Hudson Walker

Hartley's chief preoccupations in Germany were with surviving on his limited resources and with producing paintings worthy of his response to the alpine landscape. Nonetheless, in this time of political turmoil, he was hardly oblivious to the problematic situation which was developing. He adored Germans in general and once remarked that his attitude toward them began when he knew his art teacher, Nina Waldeck, in 1898 at the Cleveland School of Art. Indeed, a Bavarian town, Waldeck, is located just south of Garmisch-Partenkirchen. Fortunately, given the impressionable Hartley's political naivete, his paintings were all views of the landscape, devoid of any political reference.[34]

Hartley had a very limited understanding of the recent sinister developments in the German political situation. On January 30, 1933, Hitler had assumed power in Germany, but the following May, just after Hartley had arrived in Germany, he claimed: "I can't talk of political realities — I know little or nothing of them — only that Hitlerism does nothing to the surface of life as far as I can make out. I hear the good things he has done and they are good — outside of the Jewish question which is of course tragic."[35] For Hartley, what mattered most was that "Hitler has lowered the cost of living — food is cheap...."[36] Hartley, who loved military pageantry and had admired pre-World War I Prussian army parades in Berlin, simply extended this predilection to the Nazis, claiming "The Hitlerite uniform is pleasing."[37]

Hartley's major American supporters had often been Jewish, including his dealer Alfred Stieglitz and the expatriate collector Gertrude Stein. In 1932, Edith Halpert of the Downtown Gallery in New York presented an exhibition of Hartley's work. When he wrote to Halpert, who was also Jewish, Hartley asked her help in landing a teaching position in a private school or "a Jewish institute": "Heaven knows if love for those I know and understanding of them racially, emotionally, and spiritually — would make me a Jew, I would be one surely by now."[38] Hartley realized that "to be a member of the new party is to be anti semitic instantly," but he claimed in July, 1933, "As far as I know or have heard they are not abusing them in any other way."[39]

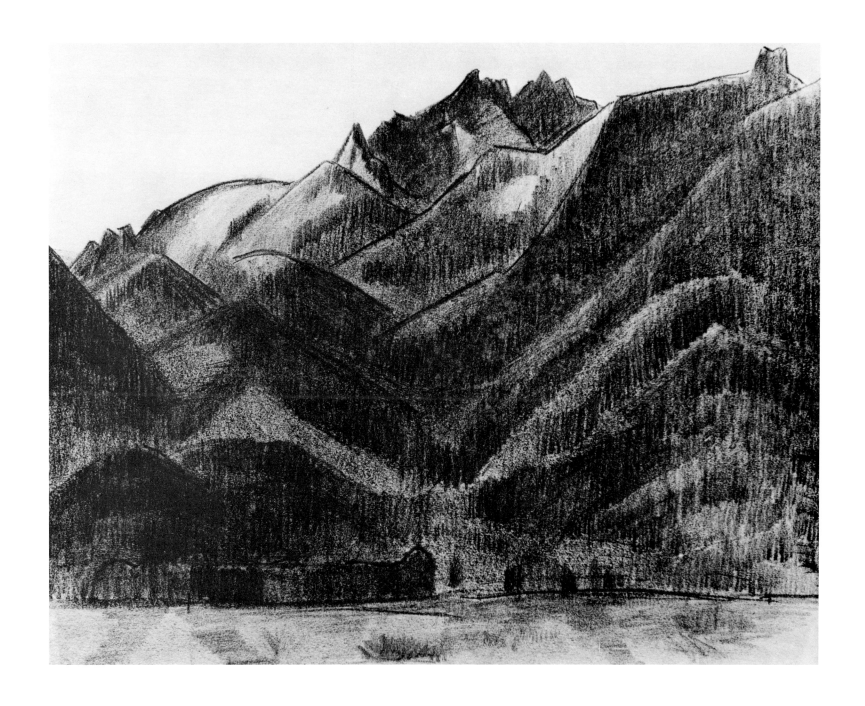

Cat. No. 29
Mountain Landscape, 1933
Conte crayon on paper, 12 5/8 x 16 inches.
Collection, Kalamazoo Institute of Arts

From his earlier stays in Germany, Hartley had a Nazi friend, Ernst Hanfstaengl, whose sister, Erna, tried to convince him that Hitler "does not hate the Jews at all, and that the best Jews have never left Germany, are still here, and are not being abused of their rights...."[40] Hartley planned to ask Miss Hanfstaengl to introduce him to Hitler whom he described as "from all accounts personally is a most nice person, and of course having wanted to be an artist, he likes artists...."[41] Evidently, Hartley was not able to arrange this meeting before he departed for America in mid-February 1934. He was never to return to Germany or to Europe; by the time of his death on September 2, 1943, the unimaginable horrors of the Nazis were not fully revealed.

Hartley's Bavarian landscapes are important in understanding the artist's subsequent development of the landscape motif. The impact of his last German experience is also clear in some of his writings which followed this period. For example, in Bermuda, in 1935, Hartley wrote poetry in an unpublished manuscript called "Tangent Decisions," in which he links Bavaria and his preceding experience with nature in Mexico:

> I have lain on the breasts
> of Alps since then,
> watched snows fall quickly
> on chill, volcano lips

In addition to observing the beautiful alpine landscape, Hartley particularly liked to watch the handsome young skiers in Garmisch-Partenkirchen and they also inspired his poetry:

> along the midriff of the
> Waxenstein.
> Long, tall, straight, sincere,
> snow-blown-deftly mountaineer

In stark contrast to his paintings of the Mexican landscape, many of which were quite imaginary, Hartley tried to record his actual observations of nature on canvas, sketching realistically on location the precise features of the Bavarian Alps. Later on, working in his

studio, he interpreted and sometimes simplified what he had seen. Hartley commented on his work in Bavaria that he sensed no distance to cause him to exaggerate what he observed, as he had in his Mexican paintings. He exclaimed: "Never in my life have I seen such expositions of nature as are revealed here — and it is almost as if I am seeing nature all over again — and what I am doing here now is the work of the rest of my life...."[42] To his German friend Arnold Rönnebeck, Hartley wrote: "My stay at Garmisch-Partenkirchen last winter did so much for me, for I settled many inner problems there and feel much better and calmer inside now & so I feel I will bring forth new qualities."[43] Thus, Hartley did not feel the necessity to further transform what he already considered marvellous. He went on to apply these lessons to his late landscape style and produced some of his greatest work during his last years which he spent mostly in his native Maine, finally painting the mountain of his dreams, Mt. Katahdin. □

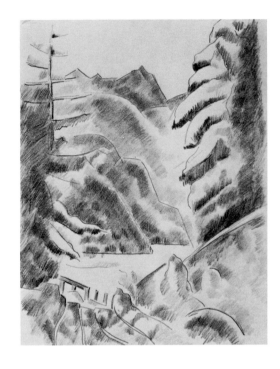

Cat. No. 28
Landscape, 1933
Charcoal on paper, 15 1/4 x 11 1/4 inches.
Courtesy, Babcock Galleries

NOTES

Excerpts from Hartley's letters have been used verbatim.

1. Marsden Hartley to Norma Berger, letter of January 29, 1934, in the Collection of American Literature, Beinecke Rare Book and Manuscript Library, Yale University, New Haven, Connecticut [hereafter cited as Yale].

2. Marsden Hartley to Adelaide Kuntz, letter of December 12, 1933, Archives of American Art, Smithsonian Institution, Washington, D. C., roll X 4; the originals of all of Hartley's letters to Kuntz are now in the Collection of American Literature, Beinecke Rare Book and Manuscript Library, Yale University [hereafter cited as AAA and Yale].

3. Marsden Hartley to Adelaide Kuntz, letter of September 7, 1933, AAA and Yale.

4. Ibid.

5. Marsden Hartley to Norma Berger, letter of September 30, 1933, Yale.

6. For a discussion of Hartley's mysticism and his relationship to Tobey, see Gail Levin, "Marsden Hartley and Mysticism," *Arts Magazine*, 60, November 1985, pp. 16-21.

7. Marsden Hartley to Norma Berger, letter of October 14, 1933, Yale.

8. Ibid.

9. Marsden Hartley to Norma Berger, letter of November 13, 1933, Yale.

10. Ibid.

11. Marsden Hartley, "Mary with the Child — of Leonardo, in the Pinakothek, Munich," in Gail R. Scott, ed., *On Art by Marsden Hartley* (New York: Horizon Press, 1982), p. 244.

12. Marsden Hartley to Adelaide Kuntz, letter of January 11, 1934, AAA and Yale.

13. Hartley, "Mary with the Child," p. 242.

14. Marsden Hartley to Adelaide Kuntz, letter of October 16, 1933, AAA and Yale.

15. Marsden Hartley to Adelaide Kuntz, letter of September 7, 1933, AAA and Yale.

16. Marsden Hartley to Adelaide Kuntz, letter of October 16, 1933, AAA and Yale.

17. For a discussion of his first encounter with the German avant-garde, see Gail Levin, "Marsden Hartley, Kandinsky, and Der Blaue Reiter," *Arts Magazine*, 52, November 1977, pp. 156-160.

18. When Kandinsky first taught at the Bauhaus, it was located in Weimar; when the Bauhaus was forced to leave Weimar for Dessau in mid-1925, Kandinsky moved with the school. When the Nazi majority in the city legislature closed the Bauhaus in October, 1932, he moved with the school to Berlin.

19. Marsden Hartley to Adelaide Kuntz, letter of November 15, 1933, AAA and Yale. Evidently Hartley was unaware that Paul Klee had left the Bauhaus in 1931 to become a professor at the Düsseldorf Academy. After he was removed from his post in April, 1933, he left Germany in December, 1933, to live in his father's house in Berne, Switzerland.

20. Marsden Hartley to Adelaide Kuntz, letters of November 15 and 4, 1933, AAA and Yale.

21. Marsden Hartley to Norma Berger, letter of November 27, 1933, Yale.

22. Ibid.

23. Marsden Hartley to Adelaide Kuntz, letter of December 1, 1933, AAA and Yale.

24. Marsden Hartley to Norma Berger, letter of December 18, 1933, Yale.

25. Marsden Hartley to Norma Berger, letter of December 30, 1933, Yale.

26. Marsden Hartley to Norma Berger, letter of January 18, 1934, Yale.

27. Marsden Hartley to Adelaide Kuntz, letter of December 1, 1933, AAA and Yale.

28. Marsden Hartley to Adelaide Kuntz, letter of July 12, 1933, AAA and Yale.

29. Marsden Hartley to Norma Berger, January 18, 1934, Yale.

30. Marsden Hartley to Norma Berger, January 29, 1934, Yale.

31. Marsden Hartley, "Tangent Decisions," completed in Bermuda, 1935, unpublished manuscript, collection of Bates College, Lewiston, Maine.

32. Marsden Hartley to Norma Berger, letter of February 4, 1934, Yale.

33. Marsden Hartley to Adelaide Kuntz, November 4, 1933, AAA and Yale.

34. For Hartley's thoughts on politics, see "Letters from Germany," *Archives of American Art Journal*, vol. 25, 1985, pp. 4-12.

35. Marsden Hartley to Adelaide Kuntz, letter of May 16, 1933, AAA and Yale.

36. Ibid.

37. Marsden Hartley to Adelaide Kuntz, letter of May 27, 1933, AAA and Yale.

38. Marsden Hartley to Edith Halpert, letter of July 12, 1933, Archives of American Art, quoted in "Letters from Germany."

39. Ibid.

40. Marsden Hartley to Adelaide Kuntz, letter of January 11, 1934, AAA and Yale. Harvard-educated Ernst Hanfstaengl, who ran his family's art reproductions business, became Nazi foreign press chief in 1933; in 1937, he was forced to flee to England after some indiscreet comments were reported to Hitler. His sister remained loyal to the Nazis.

41. Marsden Hartley to Adelaide Kuntz, letter of January 11, 1934, AAA and Yale.

42. Marsden Hartley to Adelaide Kuntz, letter of November 4, 1933, AAA and Yale.

43. Marsden Hartley to Arnold Rönnebeck, letter of March 26, 1935, Collection of American Literature, Beinecke Rare Book and Manuscript Library, Yale University. Rönnebeck, who became the director of the Denver Art Museum, was then living in the United States.

COLOR PLATES

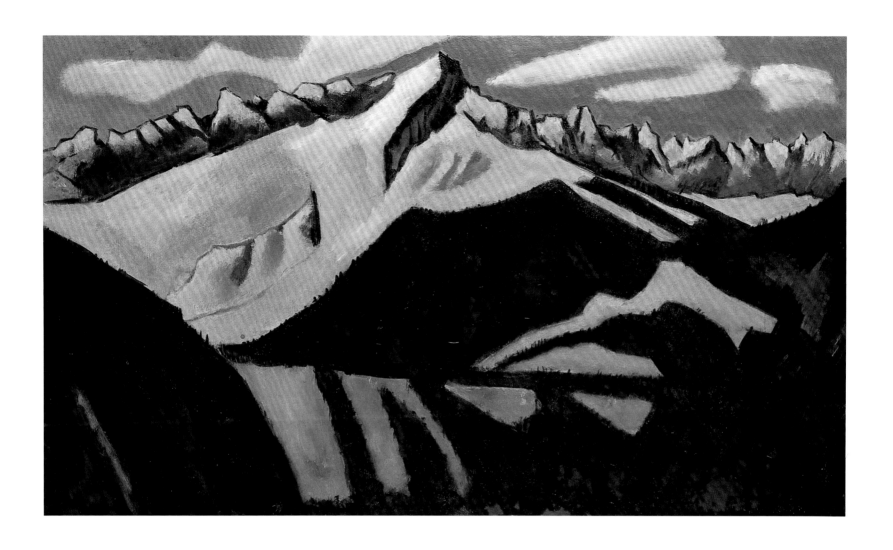

Cat. No. 1
Garmisch-Partenkirchen
[Alpspitze, Mittenwald Road from
Gschwandtnerbauer], 1933
Oil on cardboard, 17 11/16 x 29 5/8 inches.
Collection, Milwaukee Art Museum,
Bequest of Max E. Friedman

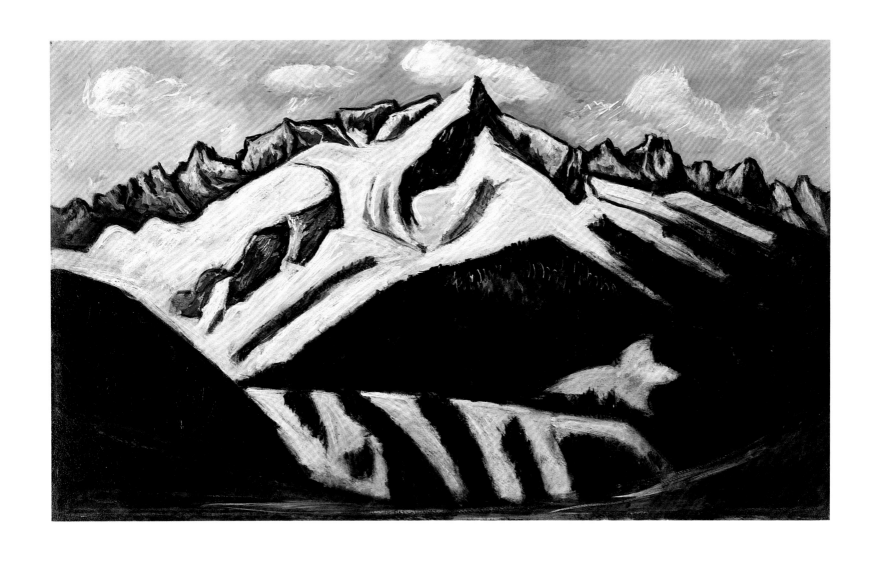

Cat. No. 2
Alpspitze, Mittenwald Road
[from Gschwandtnerbauer], 1933
Oil on composition board,
17 5/8 x 29 3/4 inches.
Courtesy, Santa Barbara Art Museum, Gift,
Mrs. Sterling Morton for the Preston Morton
Collection

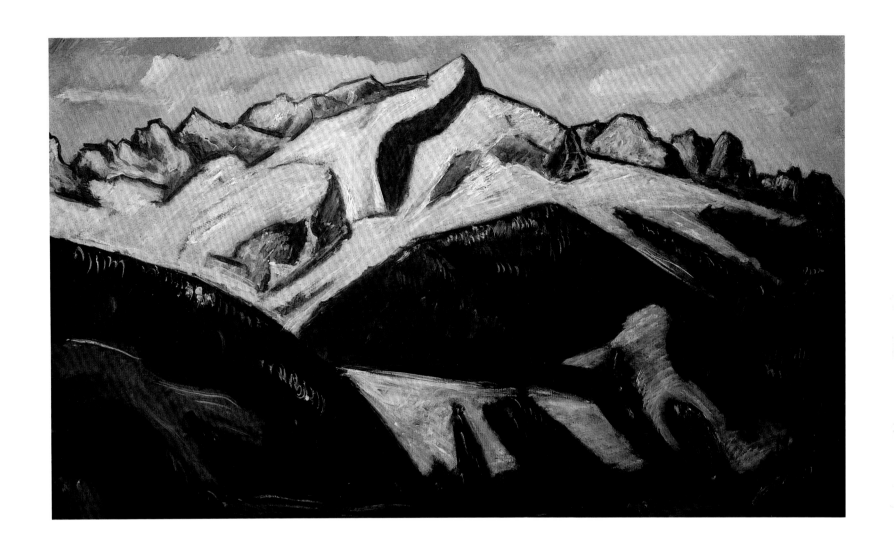

Cat. No. 3
Alpspitze, Mittenwald Road from
Partenkirchen
[from Gschwandtnerbauer], 1933
Oil on cardboard, 18 x 30 inches.
Collection, Mr. and Mrs. Nathan Weisman

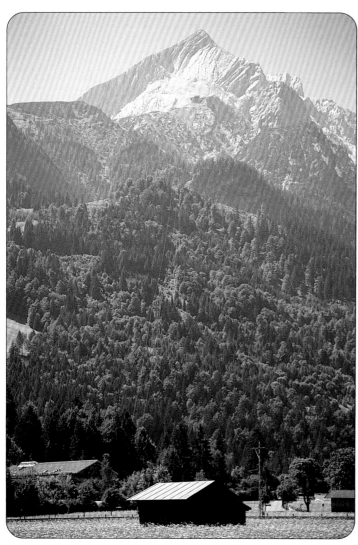

(Fig. 12) Gail Levin. *Alpspitze,* 1988.

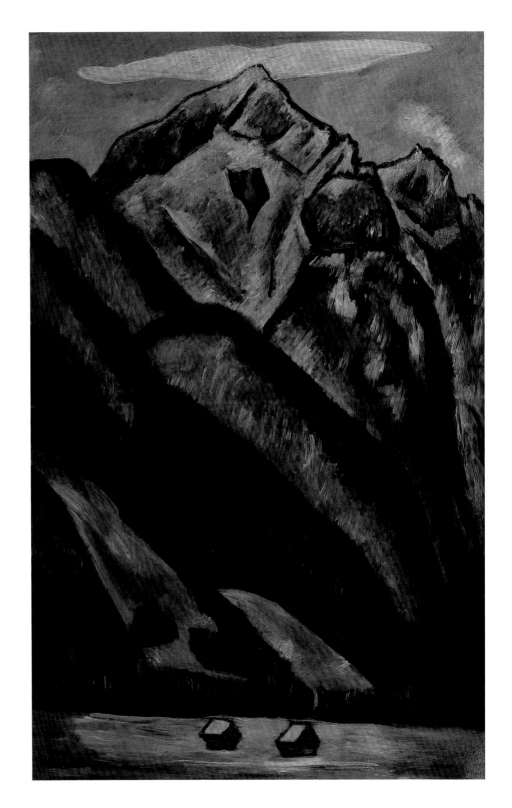

Cat. No. 5
Garmisch-Partenkirchen (Alpspitze),
1933
Oil on cardboard, 29 1/2 x 18 inches.
Collection, Sheldon Memorial Gallery,
University of Nebraska-Lincoln

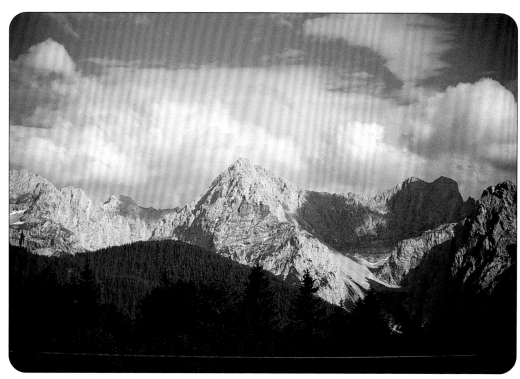

(Fig. 13) Gail Levin. *Alpspitze*, from Eckbauer, 1988.

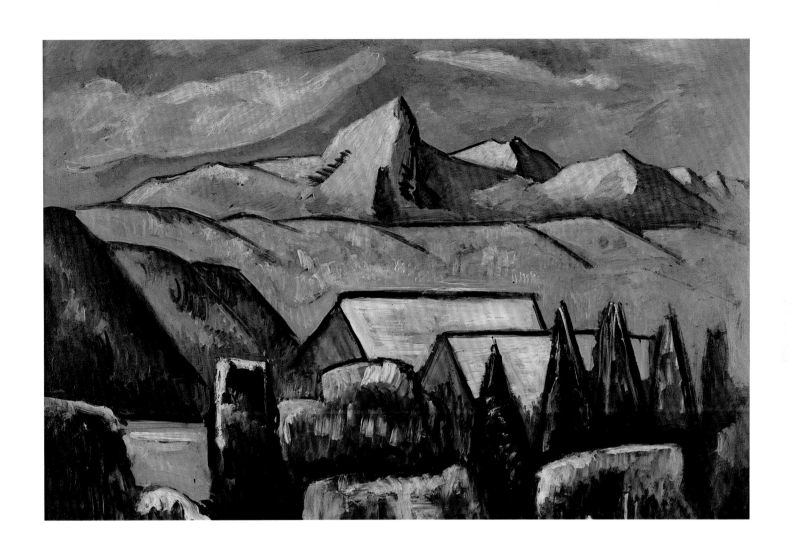

Cat. No. 7
Garmisch-Partenkirchen [Alpspitze from
Eckbauer], 1933
Oil on cardboard, 22 x 32 inches.
Private Collection, Massachusetts

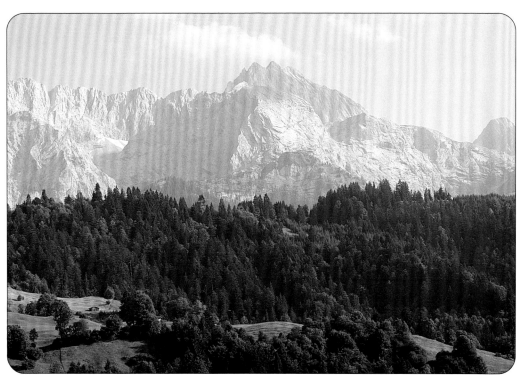

(Fig. 14) Gail Levin. *Dreitorspitze from Gschwandtnerbauer*, 1988.

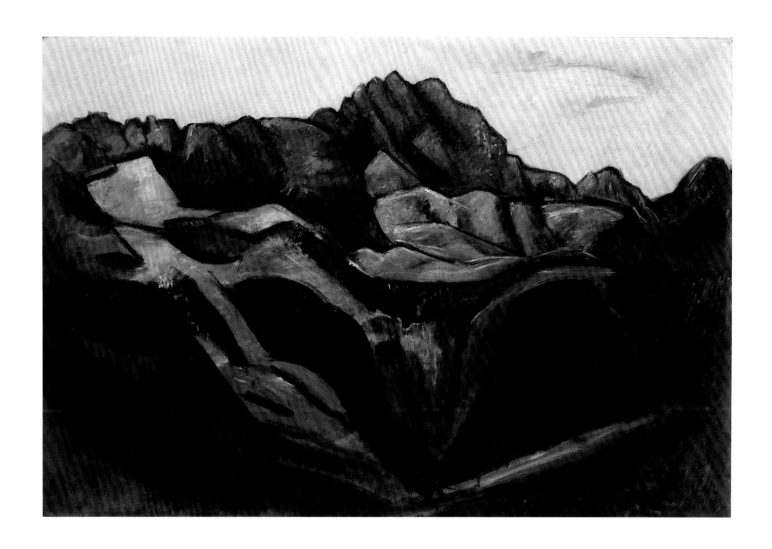

Cat. No. 8
Garmisch-Partenkirchen II
[Dreitorspitze from Gschwandtnerbauer],
1933
Oil on cardboard, 20 x 30 inches.
Courtesy, The Regis Collection, Minneapolis,
Minnesota

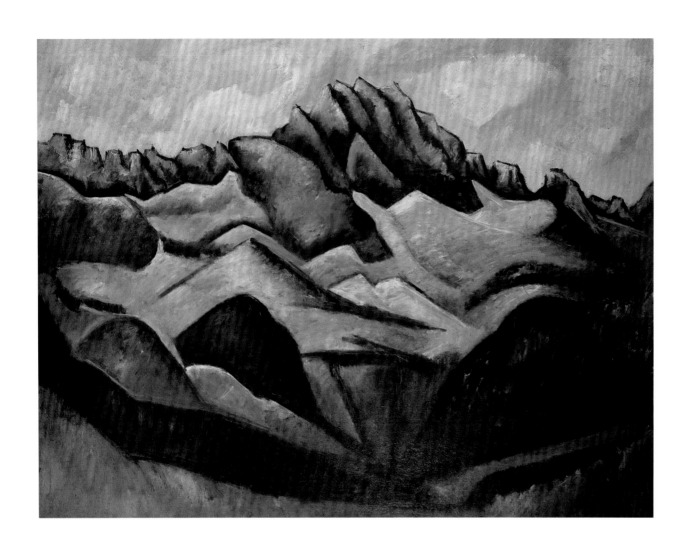

▲
Cat. No. 9
Dreitorspitze, 1933
Oil on cardboard, 25 1/2 x 32 1/2 inches.
Collection, Robert and Barbara Bachner

▶
Cat. No. 6
Garmisch-Partenkirchen [Alpspitze],
1933
Oil on cardboard, 29 3/4 x 22 1/4 inches.
Private collection

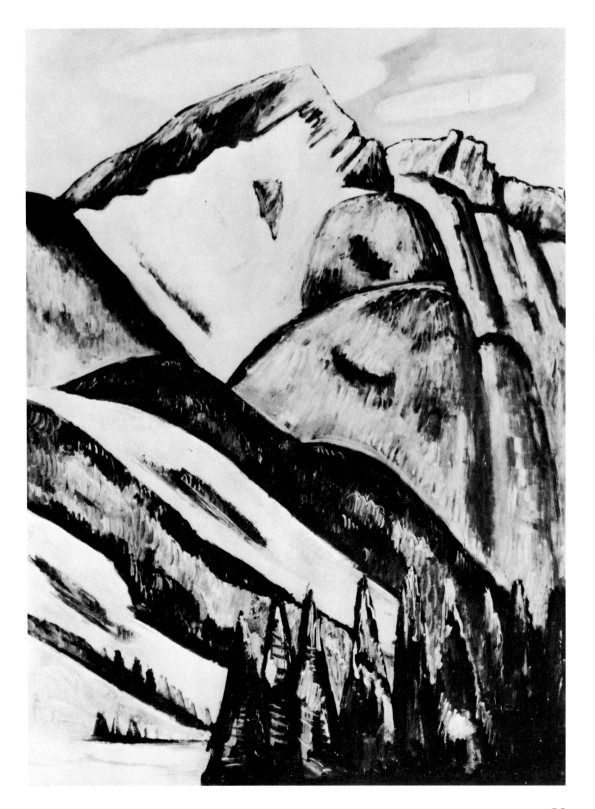

(Fig. 15) Gail Levin. *Waxenstein*, 1988.

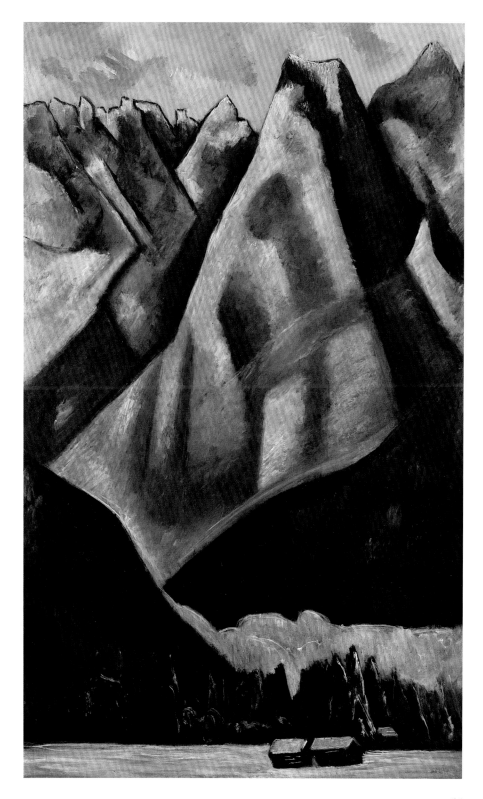

Cat. No. 10
Garmisch-Partenkirchen [Waxenstein],
1933
Oil on canvas, 29 1/2 x 18 inches.
Courtesy, Herbert F. Johnson Museum of Art,
Cornell University, Collection of Willard
Straight Hall

61

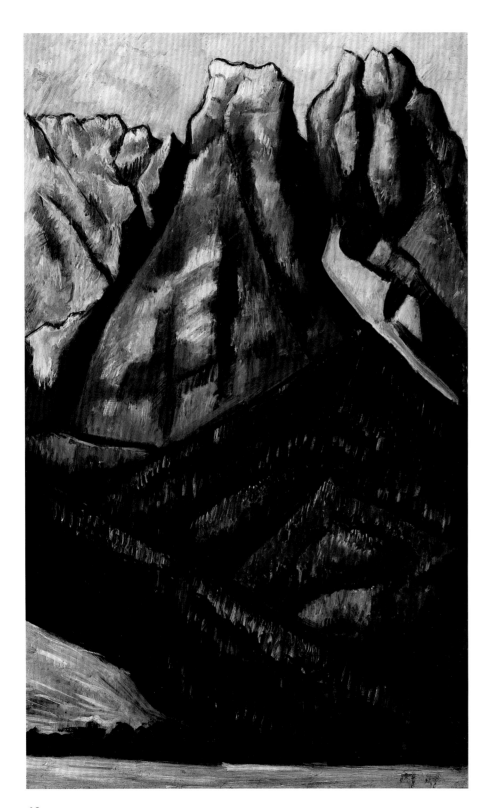

Cat. No. 11
Garmisch-Partenkirchen [Waxenstein],
1933
Oil on cardboard, 29 1/2 x 18 1/4 inches.
Collection, The Carnegie Museum of Art,
Gift of Mr. and Mrs. James H. Beal, 1959

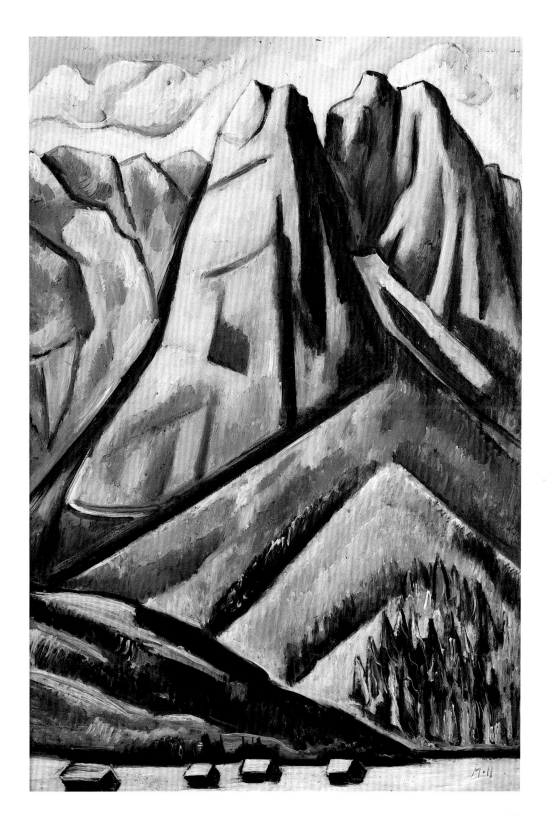

Cat. No. 13
Mountains at Garmisch (The Waxen-stein, Garmisch-Partenkirchen) 1933
Oil on cardboard, 29 3/4 x 20 3/4 inches.
Courtesy, Vanderwoude-Tananbaum Gallery

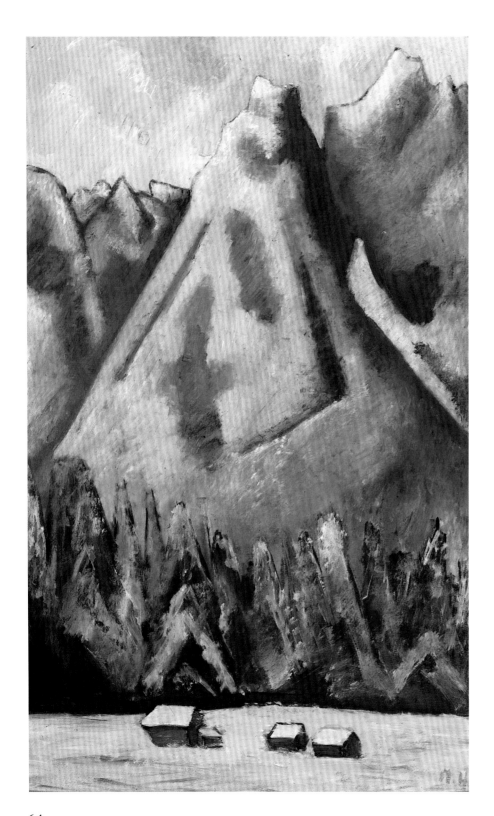

Cat. No. 12
Waxenstein Peaks, Garmisch-Parten-kirchen, 1933
Oil on canvas, 32 x 20 1/2 inches.
Collection, Yale University Art Gallery, Gift of Russell Lynes, B.A. 1932 in memory of his brother, George Platt Lynes

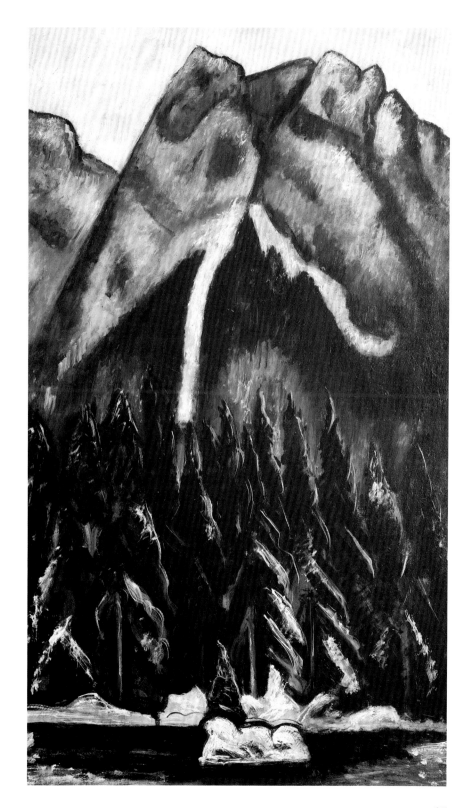

Cat. No. 15
Bavarian Alps, Garmisch-Partenkirchen
[Waxenstein from Badersee], 1933
Oil on cardboard, 30 x 18 inches.
Private collection

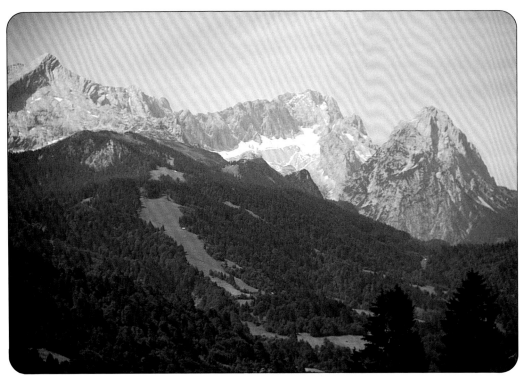

(Fig. 16) Gail Levin. *From Gschwandtnerbauer,* 1988.

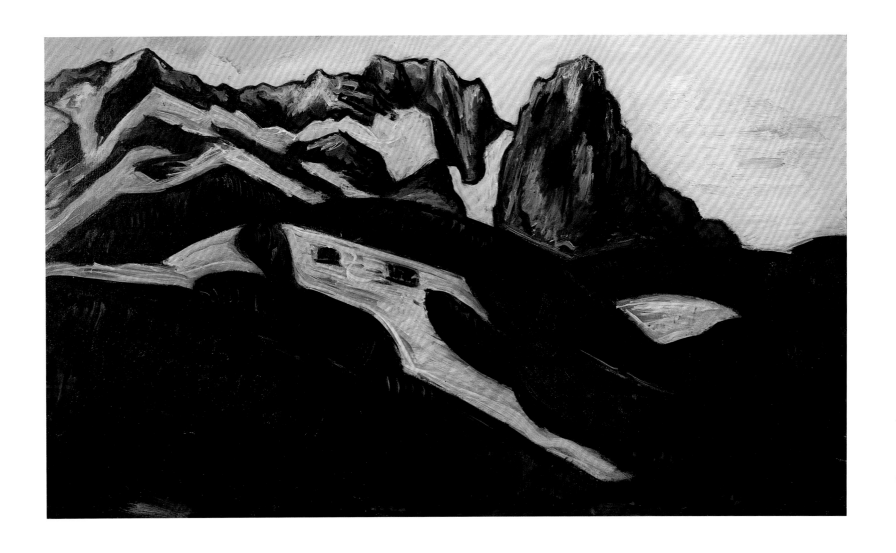

Cat. No. 14
Garmisch-Partenkirchen # 1
[from Gschwandtnerbauer], 1933
Oil on cardboard, 17 1/2 x 22 1/4 inches.
Courtesy, Heckscher Museum, Huntington,
New York

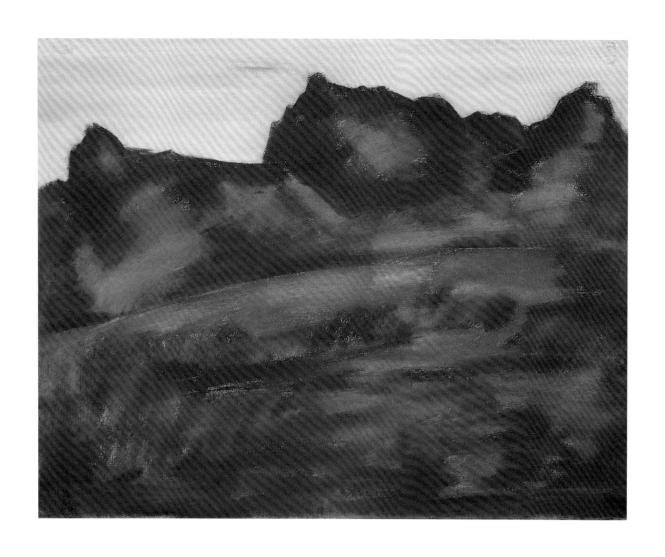

Cat. No. 16
Blue Landscape
(*Garmisch-Partenkirchen*), 1933
Pastel on paper, 15 1/2 x 20 inches.
Collection, Dr. and Mrs. Marvin Sinkoff

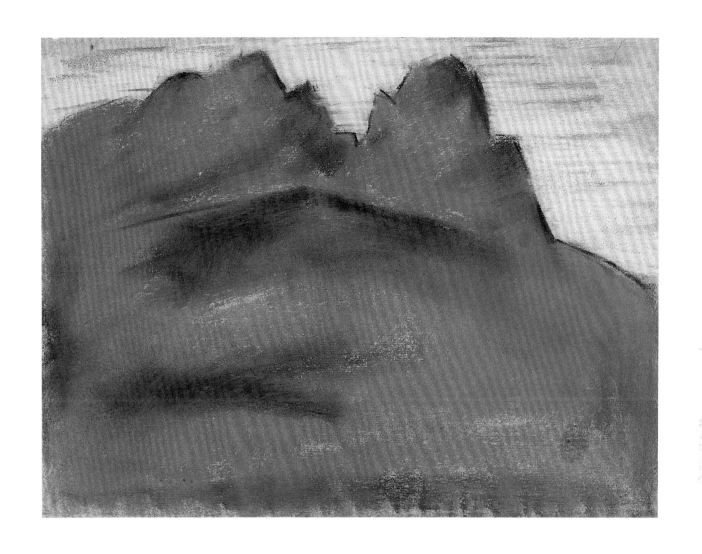

Cat. No. 17
Blue Mountain
(*Garmisch-Partenkirchen*), 1933
Pastel on paper, 8 3/4 x 11 3/4 inches.
Private Collection

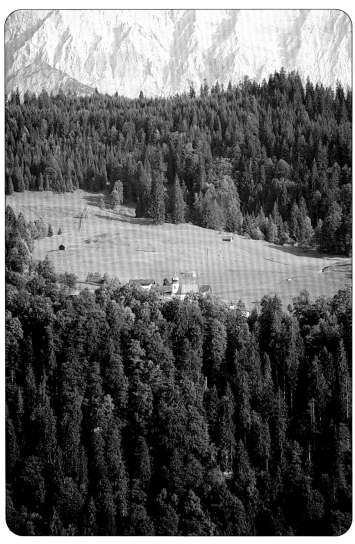

(Fig. 17) Gail Levin. *After Hartley's sketch,"Landscape with Church," 1933, from Gschwandtnerbauer,*1988.

Cat. No. 27
Landscape with Church
[from Gschwandtnerbauer], 1933
Charcoal on paper, 15 1/4 x 11 3/4 inches.
Courtesy, Babcock Galleries

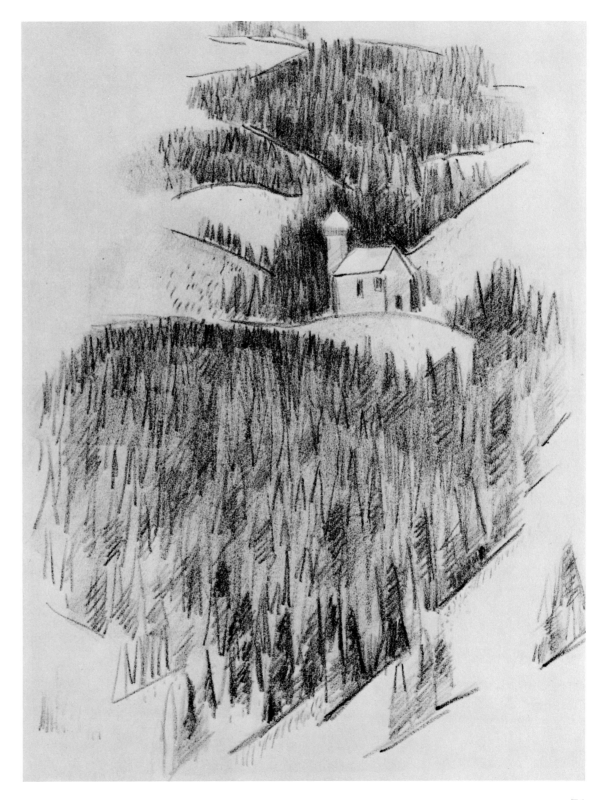

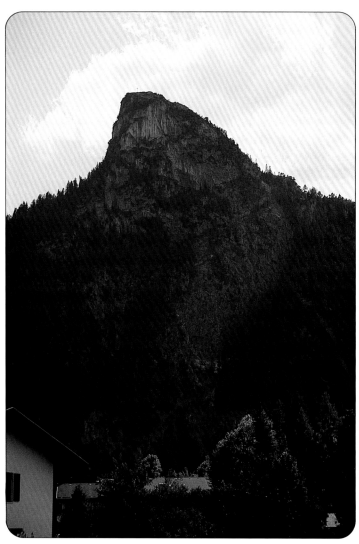

(Fig. 18) Gail Levin. *Kofelberg, Oberammergau*, 1988.

▶
Cat. No. 35
Kofelberg, Oberammergau, 1934
Charcoal on cardboard,
29 5/8 x 22 3/8 inches.
Collection, Hirshhorn Museum and Sculpture
Garden, Smithsonian Institution. Gift of
Joseph H. Hirshhorn, 1966.

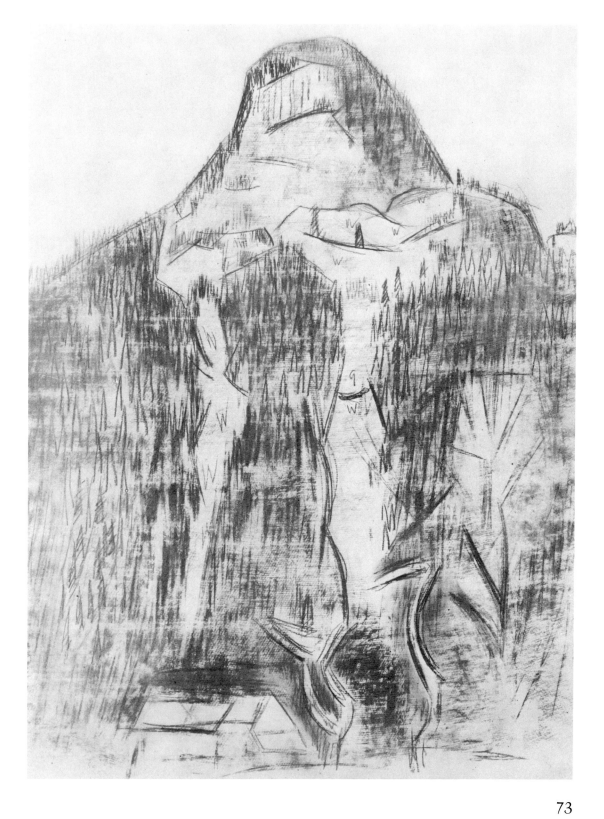

CATALOG OF THE EXHIBITION

By December 28,1933, Hartley wrote to Adelaide Kuntz that he had "nearly finished" fifteen pictures. Since these are all the oils extant today, they are dated 1933. Because it is not possible to match these works with the few titles from the series which were exhibited during Hartley's lifetime, the titles by which these works have become known are preserved here except for spelling corrections.

Paintings and lithographs are organized by locale; drawings are listed chronologically and, within the chronology, by locale. Alternate titles appear in parentheses; additional information on locale appears in brackets. Dimensions are in inches, height precedes width.

PAINTINGS

1 *Garmisch-Partenkirchen* [Alpspitze, Mittenwald Road from Gschwandtnerbauer], 1933
Oil on cardboard, 17 11/16 x 29 5/8
Collection, Milwaukee Art Museum,
Bequest of Max E. Friedman

2 *Alpspitze, Mittenwald Road* [from Gschwandtnerbauer], 1933
Oil on composition board, 17 5/8 x 29 3/4
Courtesy, Santa Barbara Art Museum, Gift, Mrs. Sterling Morton for the Preston Morton Collection

3 *Alpspitze, Mittenwald Road from Partenkirchen* [from Gschwandtnerbauer], 1933
Oil on cardboard, 18 x 30
Collection, Mr. and Mrs. Nathan Weisman

4 *Alpine Vista* [Alpspitze, Mittenwald Road from Gschwandtnerbauer], 1933
Oil on cardboard, 17 x 29
Collection, Hamilton College,
Gift of James Taylor Dunn, '36

5 *Garmisch-Partenkirchen* (*Alpspitze*), 1933
Oil on cardboard, 29 1/2 x 18
Collection, Sheldon Memorial Gallery,
University of Nebraska-Lincoln

6 *Garmisch-Partenkirchen* [Alpspitze], 1933
Oil on cardboard, 29 3/4 x 22 1/4
Private collection

7 *Garmisch-Partenkirchen* [Alpspitze from Eckbauer], 1933
Oil on cardboard, 22 x 32
Private Collection, Massachusetts

8 *Garmisch-Partenkirchen II* [Dreitorspitze from Gschwandtnerbauer], 1933
Oil on cardboard, 20 x 30
Courtesy, The Regis Collection, Minneapolis, Minnesota

9 *Dreitorspitze*, 1933
Oil on cardboard, 25 1/2 x 32 1/2
Collection, Robert and Barbara Bachner

10 *Garmisch-Partenkirchen* [Waxenstein], 1933
Oil on canvas, 29 1/2 x 18
Courtesy, Herbert F. Johnson Museum of Art, Cornell University, Collection of Willard Straight Hall

11 *Garmisch-Partenkirchen* [Waxenstein], 1933
Oil on cardboard, 29 1/2 x 18 1/4
Collection, The Carnegie Museum of Art,
Gift of Mr. and Mrs. James H. Beal, 1959

12 *Waxenstein Peaks, Garmisch-Partenkirchen*, 1933
Oil on canvas, 32 x 20 1/2
Collection, Yale University Art Gallery, Gift of Russell Lynes, B.A. 1932 in memory of his brother, George Platt Lynes

13 *Mountains at Garmisch* (*The Waxenstein, Garmisch-Partenkirchen*) 1933
Oil on cardboard, 29 3/4 x 20 3/4
Courtesy, Vanderwoude-Tananbaum Gallery

14 *Garmisch-Partenkirchen* # 1 [from Gschwandtner-bauer], 1933
Oil on cardboard, 17 1/2 x 22 1/4
Courtesy, Heckscher Museum, Huntington, New York

15 *Bavarian Alps,* (*Garmisch-Partenkirchen*)
[Waxenstein from Badersee] , 1933
Oil on cardboard, 30 x 18
Private collection

WORKS ON PAPER

PASTEL

16 *Blue Landscape* (*Garmisch-Partenkirchen*), 1933
Pastel on paper, 15 1/2 x 20
Collection, Dr. and Mrs. Marvin Sinkoff

17 *Blue Mountain* (*Garmisch-Partenkirchen*), 1933
Pastel on paper, 8 3/4 x 11 3/4
Private Collection

CHARCOAL AND CRAYON

18 *Mountain Landscape* [Alpspitze], 1933
Crayon on paper, 16 1/16 x 12 1/2
Collection, Yale University Art Gallery,
Gift of Walter Bareiss, B.S. 1940s

19 *Garmisch-Partenkirchen* [Alpspitze], 1933
Lithographic crayon on tracing paper, 13 3/16 x 9 15/16
Courtesy, University Art Museum, University of
Minnesota, Minneapolis. Bequest of Hudson Walker
from the Ione and Hudson Walker Collection.

20 *Mountains* [Alpspitze], 1933
Charcoal on paper, 12 3/8 x 15 3/4
Permanent Collection of the High Museum of Art,
Atlanta, Georgia

21 *Alpspitze*, 1933
Charcoal on paper, 13 x 9 13/16
Collection, Whitney Museum of American Art,
New York

22 *Alpspitze, Mittenwald Road from Parten-kirchen*, 1933
Crayon on paper, 10 x 13 3/8
Private Collection

23 *Dreitorspitze from Gschwandtnerbauer*, 1933
Charcoal on cardboard, 18 x 29 3/4
Collection, Tobin Surveys, Inc.

24 *Garmisch-Partenkirchen* (*Dreitorspitze*), 1933
Charcoal on paper, 18 1/16 x 29 5/8
Collection, Juliet and Michael Rubenstein

25 *Bavarian Mountains* [Dreitorspitze], 1933
Conte crayon on tracing paper, 10 x 13 3/16
Collection, The Cleveland Museum of Art,
Norman O. Stone and Ella A. Stone Memorial Fund

26 *Garmisch Partenkirchen* [Waxenstein] , 1933
Crayon on paper, 10 1/2 x 8 1/8
Private Collection

27 *Landscape with Church* [from Gschwandtner-bauer], 1933
Charcoal on paper, 15 1/4 x 11 3/4
Courtesy, Babcock Galleries

28 *Landscape*, 1933
Charcoal on paper, 15 1/4 x 11 1/4
Courtesy, Babcock Galleries

29 *Mountain Landscape*, 1933
Conte crayon on paper, 12 5/8 x 16
Collection, Kalamazoo Institute of Arts

30 *Mountains with Cabin*, 1933
Crayon on paper, 10 x 13
Courtesy, Sid Deutsch Gallery, New York, and
Owings-Dewey Fine Art, Santa Fe, New Mexico

31 *Mountains*, 1933
Crayon on paper, 12 1/2 x 16
Courtesy, Sid Deutsch Gallery, New York, and
Owings-Dewey Fine Art, Santa Fe, New Mexico

32 *Study for Bavarian Alps Series*, 1933
Crayon on tracing paper, 11 x 15 9/16
University of Michigan Museum of Art

33 Untitled, 1933
Crayon on paper, 15 1/2 x 12
Private Collection

34 *The Mountain* [Kofelberg, Oberammergau], 1934
Crayon on paper, 12 3/4 x 15 3/4
Collection, Lois Borgenicht

35 *Kofelberg, Oberammergau*, 1934
Charcoal on cardboard, 29 5/8 x 22 3/8
Collection, Hirshhorn Museum and Sculpture Garden,
Smithsonian Institution. Gift of Joseph H. Hirshhorn,
1966.

36 *Kofelberg, Oberammergau*, 1934
Charcoal on tracing paper, 12 x 15 1/2
Collection, Mr. Edward Glannon

LITHOGRAPHS

37 *Alpspitze*, 1933-34
Lithograph, 11 1/2 x 15
Courtesy, Oklahoma Art Center

38 *Dreitorspitze*, 1933-34
Lithograph, 12 1/4 x 15 7/8
Courtesy, University Art Museum, University of
Minnesota, Minneapolis. Gift of Ione and Hudson
Walker

39 *Waxenstein*, 1933-34
Lithograph, 15 7/8 x 12
Courtesy, The Art Museum, Princeton University.
Gift of Carl Otto von Kienbusch for the Carl Otto
von Kienbusch, Jr. Memorial Art Collection

40 *Kofelberg, Oberammergau*, 1934
Lithograph, 15 1/2 x 12 1/2
Courtesy, University of Maine Museum of Art

PENCIL

41 *Alpspitze*, October 11, 1933
Pencil on paper, 6 3/4 x 9 3/4
Private Collection, Baltimore

42 *Alpspitze*, October 11, 1933
Pencil on paper, 7 x 9 1/2
Collection, Mr. Gerald Ferguson

43 *Mountain Landscape, Germany* [Waxenstein],
October 13, 1933
Pencil on paper, 7 x 10
Private Collection

44 *Garmisch*, October 13, 1933
Pencil on beige paper, 9 7/8 x 7
Courtesy, Marsden Hartley Memorial Collection,
Museum of Art, Olin Arts Center, Bates College,
Lewiston, Maine

45 *Mountain Landscape, Germany*, October 13,
1933
Pencil on paper, 7 x 10
Private Collection

46 *Alpspitze*, October 20, 1933
Pencil on paper, 10 1/4 x 13 3/4
Collection, Mr. Peter Selz

47 Untitled (The Alps), October 21, 1933
Pencil on beige paper, 6 7/8 x 9 3/4
Courtesy, Marsden Hartley Memorial Collection,
Museum of Art, Olin Arts Center, Bates College,
Lewiston, Maine

48 Untitled (The Alps), October 23, 1933
Pencil on paper, 5 x 7 1/2
Courtesy, Marsden Hartley Memorial Collection,
Museum of Art, Olin Arts Center, Bates College,
Lewiston, Maine

49 *Alpspitze*, October 1933
Pencil on paper, 7 x 10
Collection, Colby College Museum of Art, Gift of
Caleb Scribner in memory of Marsden Hartley

50 *Alpspitze, Mittenwald Road from Parten-kirchen*, 1933
Pencil on white paper, 9 3/4 x 13
Collection, Mead Art Museum, Amherst College

51 *Alpspitze from Eckbauer*, 1933
Pencil on paper, 8 7/8 x 11 3/16
Collection, Georgia Museum of Art,
The University of Georgia

52 *Alpspitze #2*, 1933
Pencil on paper, 10 x 13
Private Collection

53 *Waxenstein*, 1933
Graphite on paper, 5 3/16 x 7 3/4
Collection, Roald and Susan Nasgaard, Toronto

54 *Zugspitze*, 1933
Pencil on paper, 15 3/8 x 11 5/8
Collection, Mr. and Mrs. David K. Anderson

55 *Höllen Tal Klamm*, 1933
Pencil on paper, 6 3/4 x 9 3/4
Collection, Victoria Miller, Alexandria, Virginia

56 *Garmisch, Bavarian Alps*, 1933
Pencil on paper, 10 3/8 x 14
Courtesy, Salander-O'Reilly Galleries, Inc.

57 *Mountain Crest, the Alps*, 1933
Pencil on paper, 14 1/8 x 10 1/2
Collection, The Museum of Modern Art, New York,
Gift of Monroe Wheeler

INK

58 *Alpine Motive V* [Alpspitze], October 27, 1933
Sepia ink on paper, 7 1/8 x 5 1/4
Courtesy, University Art Museum, University of
Minnesota, Minneapolis. Bequest of Hudson Walker,
from the Ione and Hudson Walker Collection.

59 *Alpine Motive*, October 27, 1933
Sepia ink on paper, 7 1/8 x 10 1/8
Courtesy, University Art Museum, University of
Minnesota, Minneapolis. Bequest of Hudson Walker,
from the Ione and Hudson Walker Collection.

60 *Alpspitze*, October 28, 1933
Pen and sepia ink on paper, 6 7/8 x 9 5/8
Courtesy, Marsden Hartley Memorial Collection,
Museum of Art, Olin Arts Center, Bates College,
Lewiston, Maine

61 *Alpine Motive VI* [Alpspitze], 1933
Sepia ink on paper, 5 3/16 x 7 3/4
Courtesy, University Art Museum, University of
Minnesota, Minneapolis. Bequest of Hudson Walker,
from the Ione and Hudson Walker Collection.

62 *Waxenstein*, October 29, 1933
Sepia ink on paper, 13 7/8 x 10 3/8
Courtesy, Babcock Galleries

SILVERPOINT

63 *Mountain Landscape, House in Foreground*,
1933
Inscribed lower right: *Eckbauer Partenkirchen Ober-bayern Sep 4 33*
Silverpoint on paper, 10 5/8 x 14 7/8
Courtesy, Babcock Galleries

64 *Mountain Landscape*, 1933
Inscribed lower right: *From Eckbauer, Oberbayern above Partenkirchen Sep 4 33*
Silverpoint on paper, 10 5/8 x 14 7/8
Courtesy, Babcock Galleries

65 *Mountain Landscape with Two Pine Trees*,
1933
Inscribed lower right: *Eckbauer Sep 4 33*
Silverpoint on paper, 10 5/8 x 14 7/8
Courtesy, Babcock Galleries

66 *Mountain Landscape with Pine Trees*, 1933
Inscribed lower right: *Waxenstein Sep 4 33*
Silverpoint on paper, 10 5/8 x 14 7/8
Courtesy, Babcock Galleries

67 *Mountain Landscape, Church Steeple in Foreground*, 1933
Inscribed lower right: *Oberbayern, Karwendel und Ellmau Sep 5 33*
Silverpoint on paper, 10 5/8 x 14 7/8
Courtesy, Babcock Galleries

68 *Mountain Landscape, with Clouds and Trees,* 1933
Inscribed lower right: *From Eckbauer Sep 5 33*
Silverpoint on paper, 10 5/8 x 14 7/8
Courtesy, Babcock Galleries

69 *Mountain Landscape with Pine Trees,* 1933
Inscribed lower right: *Waxenstein Sept 10-33*
Silverpoint on paper, 14 7/8 x 10 5/8
Courtesy, Babcock Galleries

70 *Mountain Landscape, with Building in Foreground,* 1933
Inscribed lower right: *The Two Waxensteins Sep 11 33*
Silverpoint on paper, 10 5/8 x 14 7/8
Courtesy, Babcock Galleries

71 *Mountain Landscape,* 1933
Inscribed lower right: *Zugspitze Sep 13-33*
Silverpoint on paper, 10 5/8 x 14 7/8
Courtesy, Babcock Galleries

72 *Mountain Landscape, with House and Pine Trees,* 1933
Inscribed lower right: *Zugspitze Sep-13-33 Bei Garmisch*
Silverpoint on paper, 10 5/8 x 14 7/8
Courtesy, Babcock Galleries

73 *Mountain Landscape, Buildings and Trees in Foreground,* 1933
Inscribed lower right: *The Two Waxensteins from Garmisch 9-13-33*
Silverpoint on paper, 14 7/8 x 10 5/8
Courtesy, Babcock Galleries

74 *Mountain Landscape, Two Buildings in Foreground,* 1933
Inscribed lower left: *Waxenstein Sep 13 33*
Silverpoint on paper, 14 7/8 x 10 5/8
Courtesy, Babcock Galleries

75 *Mountain Landscape, Twin Peaks, Trees in Foreground,* 1933
Inscribed lower right: *From Riesersee Waxenstein toward Höllentalklamm Sep 16 33*
Silverpoint on paper, 14 7/8 x 10 5/8
Courtesy, Babcock Galleries

76 *Mountain Landscape,* 1933
Inscribed lower left: *Waxenstein Sept 33 from Pflegersee*
Silverpoint on paper, 14 7/8 x 10 5/8
Courtesy, Babcock Galleries

77 *Mountain Landscape with Clouds,* 1933
Inscribed lower right: *Left from the Karwendel Oct 7 33*
Silverpoint on paper, 10 5/8 x 14 7/8
Courtesy, Babcock Galleries

78 *Mountain Landscape with Clouds,* 1933
Inscribed lower right: *From Gschwandtnerbauer under Wank Oct 7/33*
Silverpoint on paper, 10 5/8 x 14 7/8
Courtesy, Babcock Galleries

79 *Mountain Landscape with Clouds,* 1933
Inscribed lower right: *Dreitorspitze from Gschwandtnerbauer under Wank Oct 7/33*
Silverpoint on paper, 10 5/8 x 14 7/8
Courtesy, Babcock Galleries

80 *Mountain Landscape with Trees,* 1933
Inscribed lower right: *Karwendel Oct/33 from Gschwandtnerbauer*
Silverpoint on paper, 10 5/8 x 14 7/8
Courtesy, Babcock Galleries

81 *Mountain Landscape, Building in Foreground,* 1933
Inscribed lower center: *Eckbauer Gasthof*
Silverpoint on paper, 10 5/8 x 14 7/8
Courtesy, Babcock Galleries

82 *Mountain Landscape, Buildings and Trees,* 1933
Silverpoint on paper, 10 5/8 x 14 7/8
Courtesy, Babcock Galleries

83 *Mountain Landscape with Clump of Trees,* 1933
Silverpoint on paper, 10 5/8 x 14 7/8
Courtesy, Babcock Galleries

SUGGESTED READING

Haskell, Barbara. *Marsden Hartley*. New York: Whitney Museum of American Art in association with New York University Press, 1980.

Levin, Gail. "Marsden Hartley, Kandinsky, and Der Blaue Reiter," *Arts Magazine*, vol. 52 (November 1977), pp. 156-60.

"Marsden Hartley and the European Avant-Garde," *Arts Magazine*, vol. 54 (September 1979), pp. 158-63.

"Hidden Symbolism in Marsden Hartley's Military Pictures," *Arts Magazine*, vol. 54 (October 1979), pp. 154-58.

"Marsden Hartley and Mysticism," *Arts Magazine*, vol. 60 (November 1985), pp. 16-21.

McCausland, Elizabeth. *Marsden Hartley*. Minneapolis: University of Minnesota Press, 1952.

Scott, Gail R., ed. *On Art by Marsden Hartley*. New York: Horizon Press, 1982.

The Collected Poems of Marsden Hartley, 1904-1943. Santa Rosa: Black Sparrow Press, 1987.

Marsden Hartley. New York: Abbeville Press, 1988.

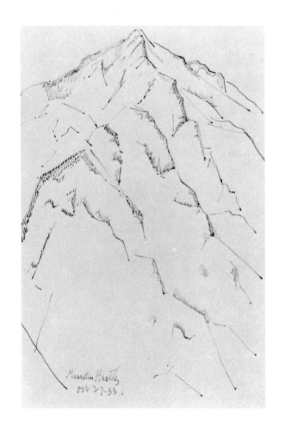

Cat. No. 58
Alpine Motive V [Alpspitze], October 27 1933
Sepia ink on paper, 7 1/8 x 5 1/4 inches. Courtesy, University Art Museum, University of Minnesota, Minneapolis. Bequest of Hudson Walker, from the Ione and Hudson Walker Collection.